Canon
EOS
650 and 620

Klaus Tiedge

AN ORIGINAL
📷 **HOVE FOTO BOOKS**

CANON EOS 650/620

First English Edition January 1988
Reprinted September 1988
Second English Edition June 1989
Reprinted October 1989
Reprinted February 1995
Published by Hove Foto Books Limited
Hotel de France, St Saviour's Road
St Helier, Jersey, Channel Islands, JE2 7LA
Tel: (01534) 614700 Fax: (01534) 887342
Printed by
The Guernsey Press Co. Ltd, Commercial Printing Division,
Guernsey, Channel Islands

British Library Cataloguing-in-Publication Data
A catalogue record for this book is available from the British Library

ISBN 0-86343-094-5

Worldwide Distribution:

Newpro (UK) Ltd
Old Sawmills Road
Faringdon, Oxon,
SN7 7DS, England
Tel: (01367) 242411 Fax: (01367) 241124

Contents

EOS Programming: DEPTH mode, the focus priority mode.

Reason: this is an example of the DEPTH mode put to good use. In the fully automatic DEPTH mode the camera automatically selects the correct aperture/shutter speed combination to obtain the greatest possible depth of field. Photo: Werner Stein

Instead of a Foreword

We are witnessing a revolution in camera technology. A modern camera can hardly be compared with the instrument that the amateur photographer once used to take his snaps. Even so, the basic principles are the same. In front is the optical system which projects the image onto light-sensitive material at the back. In between, reasonably sophisticated technical devices for measuring the exact amount of light that is allowed to expose the film. The rest is new, in some respects even revolutionary. Perhaps the comparison is not entirely appropriate, but I would say the situation is similar to that of motor-car construction where technology has responded to growing awareness of environmental factors and the fear of running out of oil. The resulting developments are quite astonishing and would have been considered impossible, even as recently as ten years ago.

The changes in camera technology are due to less ominous causes. The speed and direction of the changes are the result of quite different stimuli. Photography as a hobby has to compete against other, very attractive leisure time activities. The comparison with other media — for example electronics as a vehicle in entertainment — has also forced this type of innovation onto the world of photography. The buyer of a camera has to be convinced that he is not buying a product of the past. This seems to be assured — at least with the most recent generation of cameras. But this is only one side of the coin. If you put your new compact disc on the player, the results of the new technology are immediately apparent. But the finger on the release, even if it is a new camera, will not automatically bring a new experience in viewing the image. It is not obvious that the new camera will produce a better picture. Therein lies the difference between an active and a passive hobby. Photography requires an active person, someone who has sufficient knowledge to appreciate the basic principles of photography. The user controls the technology and the

medium; he is in charge of the gadget he holds in his hands. This need not be complicated, quite the contrary, but simple faith in the technology needs to be counterbalanced by a clear-sighted assessment of the instrument and the purpose. The aim is, and always has been, better pictures, produced by whatever means, and in our case with the most modern and sophisticated version of the good old camera.

Considerations Before and After Buying a Camera

A brave man in the photographic trade once said: "better to own no camera at all than an unsuitable one". He received little support for his comment but I appreciate this pearl of wisdom. What is the use of having a gadget that only serves to disappoint. It may be too complicated, or perhaps it does not justify the cost; it may be difficult to handle, or unsuited for the individual's purpose. The initial eagerness soon turns to frustration. Camera manufacturers have learnt to listen to the consumer. Their range of offers proves this point; they cater for every budget and photographic intent. However one thing remained wishful thinking: a tailor-made camera, but Canon have realised this in producing the Canon EOS. The only pitfall about this amazing camera seems to be its advertising. The potential buyer is led down a dangerous path. The advertising image seem to suggest that the photographer will need to do nothing but to put his finger on the button and, hey presto, the first prize in every competition is his! But taking pictures is a matter of the individual's eye, not an automatic response by a dumb machine. We could just as well say that a car with an automatic transmission releases us from the obligation to steer the vehicle. No, the amazing qualities of the EOS lie somewhere else. They lie in the range of facilities that may be recalled, when and where necessary, to take the best possible pictures under any conceivable circumstance. The Canon EOS is a deceitful siren. The array of tricks is confusing. To master

this technology you have to proceed systematically. The only guarantee of success is to master its range of facilities step by step, producing successful pictures all the way to complete competence.

Tentative Approaches

After the preamble, we can finally look closely at the camera itself. The entire design strikes us as unusual and very modern. Holding the camera in our hand we grasp, in the truest sense of the word, that its shape is not simply the result of the designer's whim, but the result of up-to-date and practical considerations. Its called "ergonomics", i.e. the design of functionality with the human handling comfort foremost in mind. Star designer Luigi Colani is supposed to have had considerable say in the original design of the most recent generation of Canon cameras. Regardless of who was responsible for the design, it deserves unqualified praise. Our hands are not designed like a vice, they have fingers and rounded shapes and this recognition has been fully considered in the shaping of the camera body. The same also applies to the operating elements. Everything is where it ought to be. It is not necessary to fumble for the release button between an array of other little buttons; the arrangement is logical and clear.

Situated in front of the release button, and also operated by the index finger of the right hand, is the electronic input dial. That this type of operating element has been re-introduced into camera construction may be called a stroke of genius. More than one hundred functions can be selected by turning this dial step by step. Which one of these functions is selected depends on which one of the other few buttons are depressed at the same time. There is no confusing array of push- or other buttons to contend with. Other important, but infrequently-used function buttons are discreetly hidden behind a flap on the camera back. Next to the viewfinder eyepiece is a second dial.

This is the central switch for switching the camera on and to select one of the simple operating modes. The display panel on the camera shoulder is the all-important function display centre. One's conclusion on first examination must be that it is an excellent solution — a minimum of operating elements control a wealth of functions.

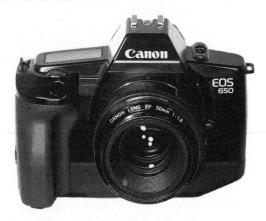

Unmistakable: Colani influence is clearly discernible in this modern design of the EOS 650. The shape is not only aesthetically pleasing, it is also highly functional.

A Complex System

Before we turn our attention to the practical side of things, we should consider a few basic principles that concern the EOS cameras, of which there are now five models. It would be wrong to think of them simply as cameras. They are part of a rather complex, completely interlinked and co-ordinated system. The Canon development engineers have not only incorporated modern principles of technology, but they have used a logical construction from the very roots to the final tips of the complex system. Moreover, the design is laid out so that it will easily accommodate further developments within the system. This book is about the EOS 650 and EOS 620. Most operating features are common to both. The extra facilities offered by the EOS 620 are described in the final chapter.

Technological Break-Through

I have alluded to the external characteristics of the EOS cameras. It may be counted amongst the species of fully automatic auto-focus SLR cameras, with electronically controlled, automatic exposure modes, focal plane shutter and integrated motor drive. This short description hides more than it reveals.

The important new feature is the electronic focus (EF) contact. This allows the fully-electronic transfer of a wide range of control signals between camera, lens and accessory. The lens bayonet comprises some features – and this is characteristic of the design concept – that point towards future developments. It is suitable for incorporating further developments and facilities without redesigning the whole system again.

The new EF lens sytem with integrated motor drive, the new autofocus metering system with the camera, the highly sensitive autofocus meter sensor, the integrated film wind

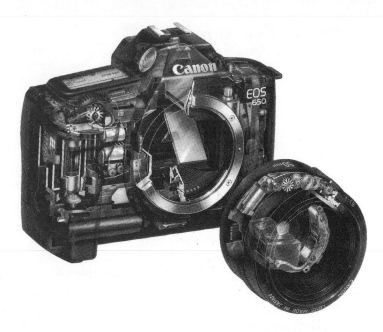

Beneath the elegant exterior hides a wealth of up-to-the-minute technology. Note the way the internal communication system continues into the lens.

motor with frame frequences of up to 3 frames per second, all these are excellent characteristics. The most remarkable thing about the Canon EOS autofocus system is that it will function in situations where a mechanical aid is better than the human eye, i.e. when lighting conditions are difficult. This has been achieved by a technical device, not unlike the low light level amplifier of the noctovisor. The practical implications will convince anyone who looks through the fast standard f/1.8 lens.

Sheer Magic — Autofocus

New technologies give rise to new terminologies. A first perusal of the manual may give you the impression that you are trying to read Esperanto! Most of the terms are abbreviations

of technical concepts. First the principle of distance metering. The EOS system uses the principle of TTL-SIR metering; this means in fact "Through-The-Lens Secondary-Image-Registration". This corresponds to the so-called "phase-registration-system" used by other well-known manufacturers such as Minolta, Nikon and Olympus.

Focusing is achieved by lens movement using the focusing point in front of and behind the main subject, until the image in the film plane corresponds to the reference images. This sounds quite complicated and is indeed a sophisticated technical situation. As far as the user is concerned, it presents no problems. The camera creates two reference images, one in front and one behind the required sharpness point of the image and adjusts these with the image in the film plane. What is truly astonishing about this process is the speed with which the camera can perform the necessary calculations and effect the necessary mechanical adjustments of the lens. The Canon's AF function works nearly as quickly as a flash and was achieved by a series of new developments and inventions.

Canon called the most important technological development BASIS; which is an abbreviation for "Base Stored Image Sensor". The computer-wise amongst you will be delighted by this new electronic marvel: a tiny — considering its output — 48-bit line sensor with appropriate amplifier circuits, consti-

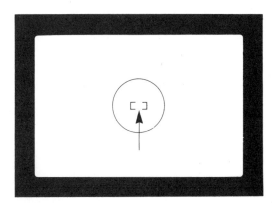

At the centre of the viewfinder screen is the rectangular metering field for the autofocus system.

tuting a real improvement over the previously-used CCD/MOS line sensors employed in other systems.

If you are interested in the technical intricacies of the construction of the EOS you can study the graphic representation and function sequence charts of BASIS, CCD and MOS. I have already mentioned the practical advantages: the BASIS control is faster and can cope even under poor lighting conditions (EV 1 for ISO 100, or expressed in exposure values: aperture f/1.4 and 1 sec.). But this specification need not necessarily be the last word for future developments. Faster systems may be developed, but one thing is certain: EOS is not only the Greek Goddess of Dawn — the Canon EOS could also be said to be Queen of the Night. Before I get too poetical at

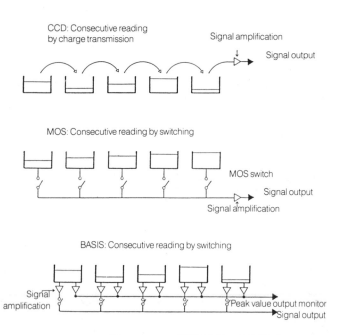

An attempt to represent the different steps of CCD, MOS and BASIS. It shows that BASIS is not only faster, it also functions with lower intensity light sources.

this point I'll bring you back to the logical and sober world of the electronics engineer; EOS is an abbreviation for Electronic-Optical-System.

Any Number of "Grey Cells"

A few more remarks for the computer buffs: the body of the Canon EOS houses a "super brain". It consists of four (yes, four!) microprocessors. This electronic expenditure was necessary to devise suitable data transfer between the super-fast and exceedingly precise autofocusing control system and the particular lens attached at the time. To start with there is the main processor which is responsible for controlling and co-ordinating the autofocus and exposure functions. Secondly there is the lens microprocessor which is responsible for the data transfer for the motorized control of aperture and autofocus. Then there is the speedlite microprocessor. The latter activates when a flashgun is used and it regulates the data transfer and zoom reflector control. And because no modern camera is complete without a databack, a fourth micro-processor was added, the back microprocessor.

Motorized Power

Microprocessors "think" and guide. But this is not enough. The application of these actions requires power — a motor. Here too the Canon engineers had some bright ideas. The camera housing contains two motors. Motor M-1 is responsible only for film transport. Motor M-2 covers three further functions. It takes care of opening and closing the shutter and moves the fold-away mirror; its third function is the automatic rewinding of the film into the cartridge. This division of duties has already proved a successful and energy-saving operation in the T90.

Canon have broken entirely new ground in their motorized

drives for these system lenses. The majority of the focal lengths have a so-called AFD (arch motor). And for a few selected lenses a complete novelty has been introduced: the USM or ultrasonic motor. This is a Canon speciality about which I shall talk a little more when I discuss the lenses in the appropriate chapters. The high technical precision in controlling and activating the lenses is achieved by the above-mentioned drives and the EMD motor which controls the lens aperture. By comparison, the motor for moving the flash reflector (zoom automatic), and for the shutter magnet to control the exposure time, seems quite a conventional construction. To summarize: The Canon EOS with its system of microprocessors and motors is built for reliability and precision whilst at the same time ensuring optimum utilisation of battery energy. Below is a table summarizing the system components that I have just described:

Microprocessors in the EOS system

Microprocessor	Function
Main microprocessor	control of autofocus, exposure and function sequence
Lens microprocessor	data transfer and EMD/AFD motor control
Speedlite microprocessor	data transfer and zoom reflector control
Technical Back microprocessor	data transfer, data storage and camera function control

EOS programming: program mode and focus priority.

Reason: A well-balanced subject, i.e. a subject with moderate contrasts and a balanced distribution of bright and dark areas, is covered satisfactorily by the fully automatic exposure mode. Photo:Werner Stein.

Control Motors	
Motor M-1	film transport
Motor M-2	shutter/mirror functions and film rewinding
Motor AFD	lens focusing (arch motor)
Motor USM	lens aperture control (ultrasonic motor)
Motor Zoom	flash reflector-zoom mode (automatic flash angle control)
Shutter magnet (2)	exposure time control

Preparing to Start

Have you studied the manual yet? If not, try it now. For a change the descriptions and instructions are quite clear and understandable. This applies in particular to the initial preparations before the camera can be ready for operation. The first time the camera is handled, it should be done with due care and attention. Let's perform these first steps: first we have to load some batteries because a modern camera cannot function without them, but the beautiful EOS will keep you looking in vain for a battery compartment. The "power house" is elegantly concealed beneath the handgrip. To get to it you have to use an old device: find a small coin and turn the screw at the right lower side of the camera. This has to be done with some care as the handgrip could either drop to the floor when the cover is released, or the camera may make a crash landing. As soon as the handgrip is released the opening for the battery can be seen in the bottom of the camera. The EOS requires

20

just one battery for all its functions, namely a lithium Type 2CR5, 6V. The plus and minus contacts are clearly marked and its shape allows only one way for insertion; it cannot be put in the wrong way, even with force, and force is never recommended as a tool for camera handling. A small orange lever will keep the battery contacts firmly connected. The handgrip can be refitted and the cover screwed back on; don't use unnecessary force.

Now you should check if the battery level is satisfactory. To do this attach a lens. Remove both front and back caps from the lens, align the red marker with the red mark on the bayonet and turn carefully clockwise. That's it. To remove the lens again, you have to depress the black release button on the left side of the camera and turn the lens anti-clockwise.

Now the battery check: the central functions switch, at the left of the viewfinder eyepiece, should still be in the "L" position. Turn this to position "A". Now we have to examine what lies behind the mysterious cover at the bottom of the camera back. This cover is held closed by a small magnet and can easily be opened with the finger-nail. Underneath the cover, the symbols indicate the functions of each button. The right-hand, black button indicates that it has something to do with the battery. Depress this button and observe the LCD panel. The legend "bc" will appear and a broken line. If the inserted battery is fresh, then the line will consist of 3 bars. With reduced battery power the line would be only 2 bars and finally only one. Practical tests have shown that it is advisable to carry a spare battery if the battery check indicates only 2 bars; 1 bar indicates that a new battery is needed at once. You should always check the state of the battery every time you start taking pictures — in particular if the camera has not been used for some time. It is not difficult to get hold of this type of battery; any photographic dealer stocks them, but you cannot pick them up at a petrol station or other casual places. Your beautiful EOS would be quite useless without a live battery and it should therefore be part of your photographic routine to make sure that the battery is fresh or you carry a spare. It

comes as rather a shock that a new battery costs about ten pounds!

Other Little Points

It is not difficult to get into the habit of checking the battery and loading a fresh one when necessary. There remains another job which, luckily, needs to be done only once — threading the camera strap. It is a very fiddly job to thread the strap and adjust it to the correct length. I still remember the time when a good camera strap was supplied with a strong snap hook.

The lens caps are another necessary evil. The front cap which protects the front element should always be within easy reach. The rear cover, which is superfluous when the lens is attached to the camera, should be stowed away in the camera bag; the same applies to the protective cover for the lens bayonet on the camera body. Former bad habits of leaving the camera bayonet unprotected can no longer be indulged in these days of electronic contacts. The delicate gold "teeth" are vital for correct data transfer and these contacts constitute the path between camera and lens to carry commands and perform the required functions. All these are merely technical details but knowing makes us aware that we are not handling a robust old cast iron pot, but an expensive piece of high tech instrument-ation. At the risk of seeming fastidious I should like to mention again: changing the lens, which we have now performed under

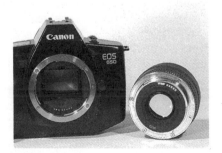

The new bayonet requires careful handling. The contacts on the camera lens mount and on the lens itself can be clearly seen. These are responsible for transfering all the data.

"controlled" conditions, has to be done carefully every time, even under conditions that are not ideal and when you are trying to catch that special moment. Anyway, it is not difficult; the solidly-constructed bayonet with precise track and the large release button allows quick and sure lens changing. The rest is easy, provided you started with good habits and have a little experience. Always remember: handle the camera calmly, with care and without undue force, and don't forget, set the central switch to "L" after use to switch it off.

Film Loaded — Camera Ready

You have charged the camera with the necessary power and fitted a lens from the range offered by Canon. To start with, the standard lens, EF f/1.8 50mm, would be the best for your initial tests. Even photographers who think they can do without a standard lens are soon convinced that the high speed of this lens is an ideal complement for the autofocus system. Enough theory and preparations; lets start to take pictures. What's missing? Of course, a film. I would recommend you take a film of average to high speed to test the camera (ISO 200/24° or even ISO 400/27°). Look at the specification on the package; it will tell you whether the film is DX coded, and this is important.

Release the camera back (depress button and move slider downwards). The back panel will open and you will see all sorts of things inside if the camera is still in its original packing. First remove the protective layer from shutter and film pressure plate. This can be thrown away. Now insert the film cartridge into the film chamber on the left and pull the film leader across until it is aligned with the orange marker. Ensure that the film lies flat and that the teeth of the transport roller engage properly in the perforations of the film.

Now set the main switch to "A" and close the rear panel. The EOS will now demonstrate one of its tricks. You hear the motor humming into action and the film is automatically wound to the first frame; the display will indicate at the same time that this function is correctly performed. The symbol for the film cartridge appears together with three bar symbols, indicating the properly transported film. Apart from this there is frame number 1. If the film is DX coded then the camera will automatically read in the film speed. Films not equipped with DX codes have to be programmed manually.

Some sceptics who don't trust automatic functions may wish to perform this manually. To program the film speed you have to open the cover at the back of the camera and simultaneously depress the brown and blue buttons. Checking the display in

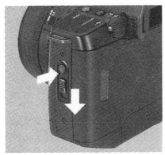

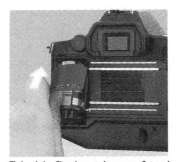

To open the back panel depress the back cover lock button and simultaneously push the back cover latch downwards.

To load the film, insert the upper flat end of the film cassette into the film compartment first, then the other end. The film load check mark appears in the display panel.

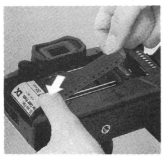

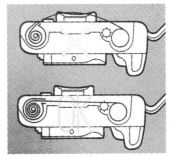

Pull the film leader across the film gate until its tip is aligned with the orange index.

Make sure that the film has no slack and that its perforations are properly engaged with the sprocket teeth.

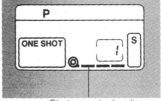

Film transport — bar diagram

Close the back cover. The camera then advances the film automatically and stops when "1" appears in the frame counter.

During film advance the film transport bars will appear at the bottom of the display panel, moving in sequence from left to right.

the panel you will either see the DX number in the ISO value that the camera reads automatically into its memory or, if the film is not coded, you can set the speed yourself. This is done quite simply by pressing the above mentioned two buttons and turning the electronic input dial in front of the release button until the required value appears in the display. The ISO display will automatically extinguish after about 8 seconds. The same thing happens if you want to check what film you loaded into the camera, if it has not been used for a while. This will not happen too often; photographing with your EOS is such fun that you will be taking pictures all the time, and the often-derided "once-a-year" picture taking will be a thing of the past.

Leave the cover open for a while to perform two other preparatory functions. First depress the brown button marked "AF" and turn the electronic input dial until the display shows "ONE SHOT"; as an alternative the term "SERVO" could appear. What this means will become clear in a little while. As a

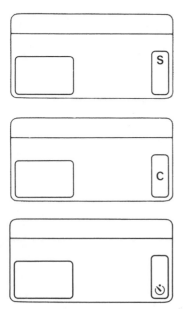

Display panel symbols for motor drive
"S" = Single shot
"C" = Continuous frame advance
(3 frames per second)
Clock symbol = self-timer

Display panel

ONE SHOT = normal setting. As soon as focusing has been achieved, the lens movement will stop and the setting will be retained as long as the release is kept depressed. This setting is particularly useful for subjects that are not to be placed at the centre of the frame. It also means that correct focusing takes priority. The release can only be activated if correct focusing has been achieved.

SERVO — means that the focusing mechanism will follow a moving subject, continuously adjusting to varying subject distances. This setting is particularly useful for moving subjects. In this mode releasing has priority over sharp focusing.

short indication: ONE SHOT means that the camera works in focusing priority, i.e. it will release only if the focus is sharp, or in other words the autofocus has done its job, and SERVO means the contrary, i.e. it works in release priority. To start with the focus priority would be the better mode to use.

Now the blue button. Depress this and turn the electronic input dial until the letter "S" appears in the right field. The alternative to this would be "C", which stands for "continuous" for a series of shots, and also the clock symbol which means that the self-timer is activated. To summarise: S stands for single shots, C for continuous shots i.e. a sequence, and the clock symbol indicates the self-timer.

Learning by Doing

Learning by doing, or trying out is better than any theory! Some enthusiasts of automation may disagree with me, but my advice is based on good practical experience. The camera has, and this is one of its essential features, one position on the main switch labelled "Full Auto"; this is the green rectangle. Even

so, I would recommend you approach your new EOS from the less automatic angle. I assume that most of you will have used a SLR camera before you opted for the EOS. Most conventional cameras of recent years have been offered with aperture priority mode. This means you preselect the aperture and the camera automatically calculates and sets the right shutter speed. Your first few shots are best taken in this program mode. To program your EOS you have to perform the following settings:

1. Main switch to "A"
2. Depress the button marked "MODE"
3. At the same time turn the electronic input dial until the legend "Av" is displayed
4. Release MODE button
5. Now turn the dial until the required aperture is displayed.

The camera is now ready to take pictures in aperture priority mode. Now we have to turn our attention to the lens. You will see two legends; "AF" and "M". As you would expect, "AF" stands for autofocus and "M" for manual focusing. As we wish to explore the benefits of automatic focusing, we move the switch to the AF position, i.e. to the front. Now we can start.

Raise the camera to your eye and look through the view-finder. This will demonstrate several advantages that the EOS can offer. The first striking feature is the viewfinder image which is very bright and clear. Then there are the viewfinder displays, all of which are logically arranged. A quick touch or

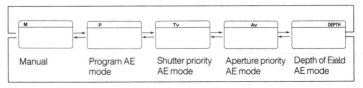

The five exposure and shooting modes and their symbols in the display panel of the EOS 650.

very gentle pressure on the shutter release button and along the lower edge of the viewfinder image is displayed the preselected lens aperture, and to the left of it a shutter speed that changes as the camera is moved to and fro, scanning lighter and darker sections of the subject.

The viewfinder display may be maintained by continuous very gentle pressure on the shutter release button. If this is removed, the display switches off after 8 seconds.

Slightly heavier pressure on the button brings the autofocus into action which seeks for a focusing point. When it has found one, the green in-focus signal lights up at the right of the viewfinder display. If the pressure is maintained on the button, the focus is held and so also is the displayed shutter speed. Further pressure on the button makes an exposure. If the button is released before an exposure is made, the focus is still held but the displayed shutter speed will alter as the subject is scanned. Again after 8 seconds the display is extinguished. The shutter will not release unless the in-focus signal is alight. Only a very small difference is pressure is required between switching on the viewfinder display and activating the autofocus

The buzzing is the sound that accompanies modern photography. For more sound accompaniment you can get your camera to issue bleeping sounds of various durations. For this effect, turn the main switch fully to the right so that the symbol against the reference mark is the little dot enclosed in brackets. The camera will now indicate the following conditions:-

○ A short audible bleep indicates that precise focusing has been obtained. This is the so-called autofocus signal.

○ Continual intermittent bleeps indicate that the shutter speed is too slow for hand-held shots. This means that you are advised to support the camera on a tripod or to use flash. Those of you who have steady nerves will be more delighted with the bleeping than those who get easily ruffled.

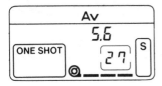

Display panel
Av = Aperture Priority. ONE SHOT =
Focusing priority. S = Single frame
shooting. Then there is the information on
what aperture (in this case f/5.6) has been
selected and the number of rames used up
(here 27) and the film symbol for the loaded
film.

The best solution in the latter case is that you silence the bleeping by returning the main switch to the "A" position.

Back to aperture priority. It is perhaps the most suitable exposure mode for photographers who have realised that a harmoniously composed picture has to present several features, and this does not always include the greatest possible depth of field. A shallow depth of field is sometimes the better creative approach and it will also serve as a test of the accuracy of the autofocus.

To check the exactness of focus you take another look through the viewfinder. The sighting area is easily recognised at the centre of the viewfinder screen; a small circle and at the centre of that circle is a small rectangle. The latter defines the outlines of the metering field for the focusing facility. Now we can put the matter to the test. Choose a subject which fills about a third of the viewfinder area and can be clearly seen against a background that is about 1.5 to 2m behind the main subject. Lightly depress the release button; the EOS hums gently and the image is in sharp focus. But what happens when the main subject is not in the centre of the viewfinder? No problem for the EOS. In the ONE SHOT focusing mode, which is the one we have selected for our first example, it is possible to store the focusing point. This is done as follows. Bring the main subject into the metering rectangle in the viewfinder and allow the autofocus to effect the setting as outlined above. Keep the release button depressed and realign the camera for the required frame. This will take just a little practice as you have to develop the necessary dexterity.

As we are dealing with the subject of selective depth of field, that is subjects that are supposed to be shown in sharp focus

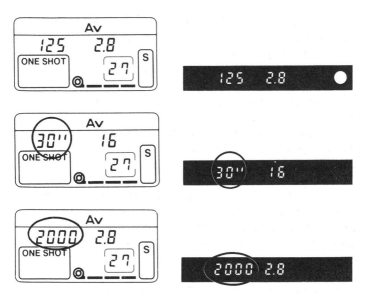

Various situations in aperture priority with different aperture/shutter speed combinations. The display on the left is always the shutter speed, that to the right is the aperture value. All this is explained in the text.

against an unimportant, i.e. more or less blurred, background we need to mention how important it is to be able visually to check the depth of field. The EOS has a depth of field check button. This is the description of the small (rather too small, I must say), button at the front, bottom right of the camera. You will find this tiny button, without legend, above the button marked "M" for manual aperture selection. This anonymous button performs an important function. Check its effect: first select the largest possible aperture opening (smallest f/number) and depress the depth of field button. Now select an average aperture value and depress the depth of field button. Now repeat the same for the smallest aperture (largest f/number). With completely open aperture, you will notice no difference, the depth of field is the same as it appears in the viewfinder image. When stopping down to average f/values, the viewfinder image becomes noticeably darker and you see

that the depth of field is increased. With the smallest aperture the viewfinder image will be quite dark, but on close examination you should see that the subject details in the foreground and background, that were previously blurred, are now in sharp focus.

This brings us directly to the subject of aperture priority and the creative use of depth of field. This topic cannot be discussed and studied closely enough. Many pictures that are admired by amateur photographers are the result of perfect control of depth of field. Another point needs mentioning here: the effect of the selective sharpness is not only dependent on the aperture, but also on the focal length of the lens used at the time. The longer the lens, the more fascinating the game with depth of field. An open aperture and a long lens will blur any unwanted back- or foreground details into a hazy cloud, emphasising the sharp main subject. It is strange that this aspect in picture creation is often not sufficiently emphasised. It can be said about many excellent pictures that the reason for their excellence is in showing rather little, but this to good effect. Practical experience with the EOS has shown that for this type of photography the autofocus is the ideal facility. Be daring — try a difficult subject and the camera will assist you most ably. Try portrait photography: the experienced portrait photographer knows that the focusing point for a portrait should be the eyes.

Shutter Speed Priority

From the technical point of view the construction of the shutter speed priority facility is much more difficult than the

EOS programming: aperture and focusing priority.

Reason: the photographer's requirement included a clearly defined depth of field. He therefore chose a small aperture (large f/number, here f/16).
Photo: Klaus Lipa

previously-described aperture priority. The user will be unaware of this technical point as from his point of view everything works just as smoothly, only in the reverse order. And how do we set the EOS for shutter speed priority?

1. Depress the MODE button.
2. Turn the input dial until "Tv" appears in the upper field of the display panel.
3. Release MODE button.
4. Turn input dial until the required shutter speed is selected. The initial speed setting is always "125".

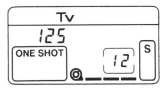

Display panel
Tv = Shutter speed priority. ONE SHOT = Focus priority. S = Single frame shooting. Also displayed is the selected shutter speed and the symbol for correctly loaded film.

Preselection of the shutter speed is particularly useful whenever you are presented with a fast moving subject. Sports photography, for example, is definitely the domain of shutter speed priority. This generalisation must be qualified with the remark: ideal provided the photographer intends to freeze the movement. Fast shutter speeds show rapid movements in sharp focus. Let's take the case of a high jumper, whom you wish to freeze at the very summit of his jump. This requires speeds of $1/125$ second or even faster. It is quite obvious that in this case the shutter speed priority with preselected times will be the safest way to a successful shot. Here too, the autofocus will prove its worth. However, in this case you should avail

EOS programming: shutter speed priority with correction by partial metering.

Reason: the subject shows wide contrast between light and shade. The photographer has to make a decision which is the more important aspect in his image creation. He metered the light area to avoid overexposure.

Photo: Hermann Groeneveld

yourself of a further facility that the EOS has up its sleeve. You can program the camera to follow fast movements. This is done as follows: Open the cover at the back, depress the brown button marked "AF" and turn the input dial until the legend "SERVO" appears at the lower left corner of the display panel.

SERVO means that the focusing priority has been cancelled. Now you can release even though the automatic focusing has not attained sharp focus; on the other hand it is possible to follow movements that may be rather fast, i.e. the focusing facility will continuously adjust to the moving focusing point. Imagine a sprinter moving rapidly towards the photographer. The highly sophisticated and rapidly reacting electronics follow the movement without any difficulty. You may have seen some quite impressive demonstrations with flying tennis balls. The only problem here is that you have to keep the subject within the target rectangle in the viewfinder. The speed limits do not depend as much on the camera as on the direction of movement of the object with regard to the photographer's position. But this is nothing new. A subject, travelling at right-angles to the lens axis requires a faster shutter speed, compared with a subject that moves directly towards the camera. Our brain and our eyes register this fact in the same way. If you are looking out of the window of a moving vehicle and you are looking sideways, you will see the line of telegraph poles whizzing by like blurred shapes. If you are looking ahead, at as steep an angle as possible to the direction of movement, you will see the same poles sharply outlined.

I do not intend to complicate shutter speed priority. The snapshot domain starts with speeds from $1/125$ second. The faster the movement, the faster the shutter speed has to be. And here too, the EOS excels over many of its rivals: its fastest shutter speed is $1/2000$ second. To be able to use these fast speeds you will generally have to opt for high speed films — depending on prevailing lighting conditions of course. Fast films are no longer an unavoidable necessity. Photographic technology has advanced in recent years and films of ISO 400/27° are now standard for sports photography.

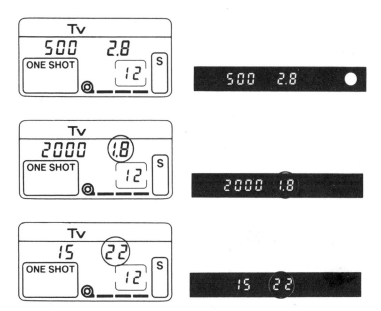

A comparison of different LCD panel and viewfinder displays in shutter speed priority mode (Tv). On the left the preselected shutter speed, next to it the automatically selected aperture value. See the text for more information.

We have spent quite some time in expounding the merits of shutter speed priority and short exposure times. But the exact opposite could be the correct creative medium in some situations. The above-praised sharp rendition of the movement, the frozen instant, is one thing, the dynamic representation of speed is another.

I am talking here of the technique of moving the camera with the subject movement, known as "panning". One example: a sprinter moves at right-angles to the direction of shooting. You could catch his movement in sharp focus with a fast shutter speed. Or you could try to create the illusion of the movement by allowing controlled blurring of the contours. To do this you have to choose a slower shutter speed. In the above example $1/60$ second would be a suitable speed. The rest is up to the photographer's dexterity in following the movement of the

sprinter. The better synchronised your movement with that of the subject, the sharper the sprinter against a blurred, or rather "wiped", background. The panning technique is a wonderful one for experimentation, the ideal medium for using colour film. It is also a good trick for differentiating the incidental from the important, to create an effective "accent" — the optical climax. The range of shutter speeds within which such experiments should succeed are from $1/8$ to $1/60$ second. The slower the chosen shutter speed, the more critical the ability to follow the subject and the more blurred the background. Practice makes perfect and this applies in particular to panning.

Automatic Mode

This may be the favourite mode for a first trial with the EOS. The full auto mode is a wonderfully convenient thing. The necessary evil: the camera does everything and the user need not have any idea how these technically perfect pictures are obtained. This total "brain-override" mode should really be banished to the field of pocket cameras. Everyone who has a SLR camera, and in particular the owner of such high tech equipment as the EOS, belongs to a different class of photographic animal. The real enjoyment in photography grows with the intentional and considered application of technical means, or in other words, with creativity. Even so, fully automatic mode should not be rejected out of hand. Even the ambitious photographer knows of situations where the comfortable and absolutely safe handling of his camera has to be preferred to other methods of picture making. I shall leave you with the statement that the EOS can offer this type of picture making.

Programming the camera is as easy as shooting. The "go ahead" for the snap-shooter is given by setting the camera's main switch, next to the viewfinder, to the green square symbol. Obviously the sliding switch on the lens should be set to AF, i.e. autofocus. Provided you have loaded a DX coded

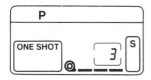

Display panel
P = Program mode. ONE SHOT = Focus priority. S = single frame shooting. Also displayed is the symbol for correctly loaded film and the number of frames (here 3).

film, you will not have to do anything else, apart from pointing the camera at the subject and depressing the shutter. What is displayed on the LCD panel and what goes on? ONE SHOT will appear in the display panel; this is the autofocus program for fully automatic focusing. Then you will see P for program, i.e. fully automatic exposure mode. The third symbol will be S, meaning single shot.

The photographer has no influence on the aperture and shutter speed settings. Even so, you are not totally unaware of what is being decided for you. The values chosen by the program mode will be displayed both in the viewfinder, and in the display panel and a continuous bleeping will indicate if the shutter speed is not fast enough for shake-free shooting. In this case you may have to use flash or load a faster film.

For those totally inexperienced photographers who have never handled any modern SLR camera, I should mention that the release button has two functions. Depressing it lightly will activate the displays and also the autofocus to find the focusing point. When the in-focus indicator lights up depressing the release button fully will trigger the shutter. The displays will remain lit for about 8 seconds after the button is released. This is another important point: as long as the release is held depressed, the initially selected focus setting remains locked, even if the subject or the distance to the subject has been changed. Should the autofocus be unable to obtain a correct setting, then the green AF signal will blink, and the shutter cannot be released.

Should the automatically programmed shutter speed be too slow for hand-held shots, a long electronic warning signal will sound. If a correct exposure setting cannot be obtained, then both the shutter speed and the aperture will blink. In case of

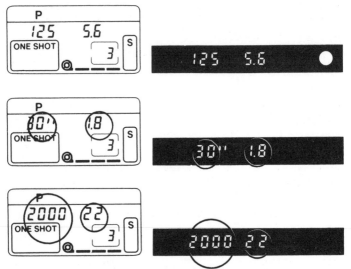

A comparison of different LCD panel and viewfinder displays in program mode. The circled exposure values here — shutter speeds and aperture values — mean the greatest or lowest values that may be obtained by automatic settings.

insufficient lighting, you can use flash. You will be given an underexposure warning for speeds from 30 seconds. This is also the time that will blink in the viewfinder. Overexposure should be a rather rare occurrence. If it arises, then the fastest shutter speed of $^1/_{2000}$ second will blink and also the smallest aperture of f/22. The simple remedy in this situation would be to use a neutral density filter. For most of us this may be a purely theoretical solution. After all, who has a ND filter handy at all times? The next possibility is to change to a slower film.

As I am on the subject of films here too the EOS has more helpful facilities at its electronic finger-tips. As soon as the film is finished, it will be automatically rewound into the cartridge. During the rewinding process the bar symbols for the film transport control move from right to left and the frame counter counts backwards. The film cartridge symbol in the display panel will blink as a warning not to open the camera back too soon. The EOS would not be the fine camera it is if it did not

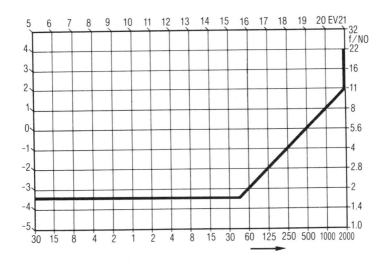

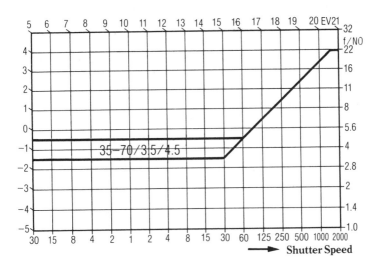

Program curves (shutter speed/aperture value combinations) for fully automatic and program mode.

41

have another trick up its sleeve for the "full-auto" program mode. This variation is called AE-program mode. The principles, according to which the camera selects the correct aperture/shutter speed combination, are the same but the way it arrives at these is different. The main switch is set to "A", then you have to depress the MODE button. Selecting the program is done via input dial. The display will show "P" as before. The camera will automatically select "one-shot-AF-program" and "S" film transport mode. It is also possible to use the "Servo AF" and the "C" film transport mode in this program mode. To conclude: the AE program is always useful when a choice between focusing or release priority and film transport speed is desirable but you still wish to use the automatic program mode.

For those of you who are interested in the technical basis of the EOS, I should like to include the following explanations. The EOS is equipped with the newest "automatic self adjusting program", which selects the best possible aperture/shutter speed priority suitable for the particular lens attached at the time. In case the automatically-selected shutter speed lies 0 to 0.5 stops below the focal length of the lens, a warning tone will sound. One generally assumes that the slowest shutter speed at which shake-free pictures may be ensured with reasonable certainty is the reciprocal of the focal length of the lens in mm. To state some examples; $1/125$ second would be suitable for a focal length of 125 mm; $1/250$ second would be the lower limit for a 250mm lens. The shorter the focal length, the slower the possible shutter speeds for hand-held shots. Below I have included the program curves for the EOS program mode.

Depth of Field Mode (650 only)

We could have tried to place bets on what ideas camera engineers would next dream up to improve handling convenience even further. What else could be automated? The Canon designers have found it! They have mastered the phenomenon

of depth of field. And what does this mean in practice? The EOS has a depth of field program which is designed in such a way that the smallest possible aperture is selected for any given set of circumstances, i.e. to always ensure the greatest possible depth of field. Using the AF program and the DEPTH mode allows you to show everything in sharp focus from a certain point down to the background. The camera selects automatically the correct aperture value and the appropriate shutter speed for the given lighting conditions. These functions are particularly suitable for landscape and architectural photography.

This is how it's done: depress the MODE button and turn the input dial at the same time until "DEPTH" — the symbol for depth of field — appears in the display panel. Now the metering. First point the metering rectangle in the viewfinder at the closer point which needs to be in focus. Depress the release button lightly to focus on this point. Then point the focusing area at the furthest point and repeat the focusing process. Now depress again lightly and the aperture value and shutter speed selected by the camera will be displayed in the viewfinder. Now you can take the shot. The camera will have calculated the difference in distance between the close and far points and worked out exactly what aperture value will cover this depth of field. This is a fascinating process, although I have to mention here that the depth of field display on the lens fulfils the same function, only in the latter case it is necessary to set the appropriate aperture value by hand. The EOS, on the other hand, will do it all for you together with viewfinder and liquid crystal displays.

Beware of some pitfalls, though. You may find yourself

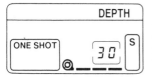

Display panel
DEPTH = Depth of field mode. ONE SHOT = Focusing priority. S = single frame shooting. Further information displayed: film loaded (cartridge symbol), 30 frames taken.

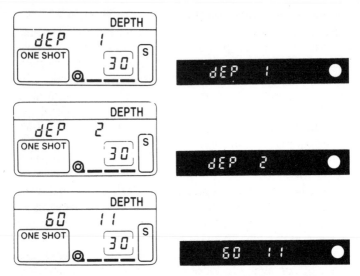

A comparison of different monitor and viewfinder displays. dEP 1 means that the first focusing point has been metered (foreground), dEP 2 is the signal for the second point (background). The shutter speed/aperture value combination is then shown in the lower display panel in the viewfinder.

carried away by all this technological progress and select a relatively wide depth of field in rather poor lighting conditions. This may take you into rather slow shutter speeds that are unsuitable for hand-held shots. But this is no real tragedy; the camera will warn you by a long bleep tone. You can then either use a tripod, or attach a shorter focus lens. Shorter focal lengths have greater depth of field.

Let's call a spade a spade and state that the depth of field mode is a most fascinating technical device, but its practical use is not quite as sensational. However, you may find it useful, and of course, it works with flash as well.

The EOS owner soon comes to the conclusion that the best thing is to try it out. The more conversant you are with the full extent of the AF facilities, the better the mastery of the subject.

EOS programming: program mode and focusing priority.

Top: an exposure correction here of +1 was effected to compensate for the back-lit scene.

Reason: the program mode is absolutely reliable in giving you perfect exposure readings, particularly if used with wide-angle and standard lenses — apart from subjects lit by extreme backlighting. Photo: Klaus Lipa

ual Too

Don't get any wrong ideas! Manual does not have the same meaning with the EOS as with a conventional camera. In this case too, a most sophisticated system of operational combinations, all designed with the same aim in mind: to obtain the best possible picture under the most difficult circumstances. The user has to have some know-how to use the manual facility. On the other hand, it is not necessary to have a degree in photography to appreciate the manual mode on the EOS. Let's proceed step by step to explore the situation. First you

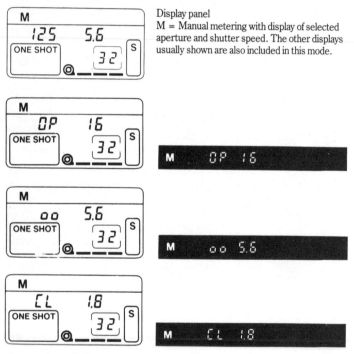

Display panel
M = Manual metering with display of selected aperture and shutter speed. The other displays usually shown are also included in this mode.

A comparison of LCD panel and viewfinder displays with manual exposure metering. Top: OP stands for "open" i.e. the aperture should be opened up for correct exposure. Centre: oo is the symbol for correct exposure. Bottom: CL stands for "close" i.e. stop down the aperture for correct exposure.

depress the MODE button and turn the input dial until "M" appears in the display panel. Together with the M, $1/125$ second and 5.6 will be displayed. This is the starting position. Keep on turning the input dial until the required time between B, long exposure, and $1/2000$ second, the fastest possible shutter speed, is indicated.

The aperture can be selected manually. To do this we have to have another,closer look at the EOS. At the front to the right of the lens is a little button marked "M". Depressing this button brings manual aperture control into action. This is how it's done: depress the M button and turn the input dial. Depending on the direction you turn, the aperture value will increase or decrease.

The manual setting of aperture and shutter speed could be useful if you take a light reading with a manual exposure meter because of unusual lighting and subject conditions, or you wish to obtain certain effects by using a preset aperture/shutter speed combination. However, programming the EOS to M does not inactivate the entire exposure metering system. Any conceivable, precisely defined, over- and underexposure is possible in manual mode.

Creative Metering — Professional Metering

I have spent several pages on the blessings of modern electronics, and with good reason..After all, this is the measure of technological progress. However, we need to keep one thing firmly in mind: all the electronic expense is invested purely to control the exposure level, and not the actual metering. Whether the exposure is controlled by the most up-to-date technology is, strictly speaking, only of secondary importance. The first and foremost step is the metering of the subject and to be able to convert this result into the appropriate exposure values. Again, you can trust the Canon designers absolutely in this respect. This problem too was solved in the

most original and perfect manner. The fascinating concept about this camera is the fact that is was not only designed with the aim to the best possible handling comfort, but also with the definite purpose of setting a perfect picture into the foreground of the design brief.

The result is the so-called evaluative metering system. First a little introduction. The basic premise was again the method of autofocus setting. Because the main subject has to be at the centre of the viewfinder screen, the metering system of the EOS measures the subject brightness at the moment when focusing takes place, also considering the surrounding subject space. Well and good, you may say, what else do you want? Unfortunately, the matter is not as simple as all that. Based on the necessity that the photographer points the focusing area of the autofocus system at the most important subject point, the point which has to be in sharp focus, this is also the point where subject brightness has to be metered. But this is true only under certain conditions. If we take a subject with average contrast values, then the metering has to be designed to find the best possible compromise for the given situation. A balance has to be found to show some gradation in the darkest shadows and at the same time retain some detail in the brightest areas. The metering system in the EOS therefore considers not only the central area of the frame, but also the peripheral zones. The two areas around the centre point could be likened to the centre-weighted integral metering used in a range of other cameras. But contrary to other measuring systems, the EOS does not treat the rest of the frame as a uniform, closed area, but subdivides it into a further four measuring zones.

The multi-zone metering is divided into three regions: metering of the central field, metering of the circular field around the central area and metering of the four peripheral zones. The brightness values in each of these zones are ascertained and the results of these measurements — and their distribution within the frame — are evaluated and conclusions drawn as to the nature of the entire subject.

Whether the subject is lit directly or backlit, whether there is a dark background or a particularly dark or bright subject, the camera will endeavour to draw the right conclusions. One could say that the camera memorises a number of situations and makes comparative assessments with the given situation, in order to calculate the appropriate aperture value/shutter speed combinations according to the selected program mode.

A diagram of the exposure metering characteristics of the EOS. Apart from the centre-weighted segments, the areas towards the sides are also properly evaluated.

This comparative metering is a new development from the centre-weighted integral metering system. It is important to know that this new method will produce optimum exposure in all those cases where the integral metering system has functioned so well up to now. This trick was achieved by centre-weighted logarithmic average values, based on the brightness evaluation of the three metering zones. But even the best and most sophisticated system has its limitations. In 70 out of 100 cases we can implicitly rely on the evaluative metering system of the EOS. If we are not all that critical in our demands we could say that this percentage is even higher.

The EOS has not been designed for the uncritical however. This is a camera that not only impresses us by the wealth of its facilities, but by the clever provision of override facilities by which the photographer can take direct and intelligent action. The know-how of the photographer grows with handling. The EOS challenges you to take better pictures by making use of its many facilities. The ambitious slide photographer will soon recognise the range of creative facilities under his own individual control for obtaining the very best from each situation.

I would like to state clearly that individual and correctly

applied metering, together with the choice of the correct focal length and well handled control of depth of field, is the path to creative photography.

When You Think, It Thinks

Even the most effective metering system and the most perfect exposure control cannot be a substitute for the trained and imaginative eye of the experienced photographer. The EOS designers have been honest enough to admit this fact and we note with approval how this was heeded without creating considerable difficulties for the user. The EOS makes it easy for the photographer to optimise results by pressing a button.

I would like to summarise once more: the metering sensor is divided into three areas and six zones. These are the central areas for measuring the main subject provided it is located at the centre of the frame, then the circular area around the central area. Lastly there are four equal-sized zones outside the central area for the accurate metering of the surrounding area. Let's look again at the diagram. This demonstrates very clearly the metering characteristics of the multi-zone photo diode. By the way, the thick black demarcation lines are no free artistic addition, but symbolise the non-conductive insulation between the individual metering zones.

The following three points outline the difference between the metering system of the EOS and other systems:

○ The EOS metering system is "main subject weighted". For autofocus shots (one shot) — the most frequently-used method — the metering system measures the brightness

EOS programming: shutter speed priority with release priority.

Reason: to obtain the blurred effect of the flowing water a slow shutter speed was preselected. In this case $^1/_{15}$ second. The camera was placed on the tripod. The depth of field is only of secondary importance in shots of this type.

Photo: Hermann Groeneveld

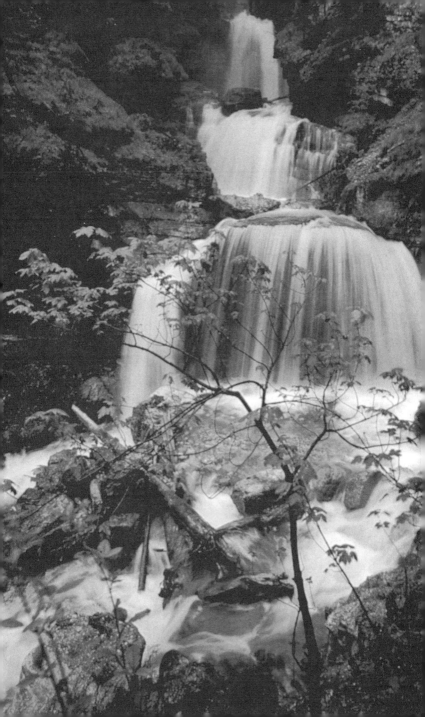

just as the focus is locked. This means that the main subject is at the centre of the viewfinder screen. This ensures that the main subject is the predominant consideration.

○ The EOS metering system combines the characteristics of multi-zone metering with those of centre-weighted integral metering. For this reason these alternatives need not be selectable.

○ The EOS metering system offers the best possible performance for a whole range of photographic conditions. Moreover, it is designed to adjust easily and quickly to the given situation to produce correct and reliable results.

It has been found in practical use that the EOS metering system is capable of producing the ideal exposure values even in situations where other systems would meet with problems — even in critical situations such as backlit subjects where the main subject is rather small in relation to the overall frame.

Let's consider the practical side: the EOS offers facilities that other manufacturers don't even include on cameras that are aimed at the professional market. One example is partial metering. By simply depressing a button the metering area is concentrated on the central area of the frame. If I said earlier that the system of multi-zone metering is capable of coping with difficult situations, I would like to add that there will always be subjects where the photographer has to meter certain small areas to obtain the best result. The partial metering field measures about 6.5% of the viewing area. In addition, the EOS has a metering lock in connection with the partial metering facility which may be considered a professional luxury.

To take it step by step: the partial metering facility is activated by depressing the little button on the top right rear side of the camera body. This will inactivate all other metering zones, apart from the circular area at the viewfinder centre. To

EOS Programming: for a romantic "soft" rendering of the image it was intentionally a little underexposed. This was done by a manual exposure correction of -1 stop. *Photo: Klaus Lipa*

meter the subject you point the camera at the important detail so that it is within the central circle of the viewfinder. The camera will take an exposure reading on depressing the release button lightly and keep this value locked as long as the partial metering button and the release button are kept depressed. Now you can realign the camera to change the frame if the main subject is to be off-centre, and fully depress the release button to trigger the shutter. The result will be a precisely focused and exposed shot of the important detail without any interfering factors being taken into account. And when would you make use of this facility? For example with very contrasty subjects, where the camera would not be able to decide which section was the important one to express the photographer's intentions. Typical subjects are stage scenes and portraits in strong backlighting and all other subjects where the main area possesses completely different lighting characteristics from the surrounding area.

Partial metering may be used with almost all the shooting modes. The only exception being the full auto program mode. This makes sense, after all, the full program mode has been provided as a fast and uncomplicated snapshot mode. Is it possible to take a sequence of frames with exposure lock in this metering mode? Yes, of course, and it is quite simple. If the lighting conditions remain unchanged and you keep the release button depressed after each shot, to retain the exposure value, you can take as many frames as you wish.

To start with you may think that all this is quite unnecessary. With increasing experience you will come to appreciate this type of metering, particularly as it is so easy to change the metering mode with the EOS. I would recommend that you experiment a few times to learn to appreciate its worth. You will be rewarded with better pictures; pictures that express the mood of the situation.

To use the camera will convince you more than any words that I could write. The when and how of partial metering is best learnt by making comparative shots. In case you are unsure, take one frame in the evaluative metering mode, followed by

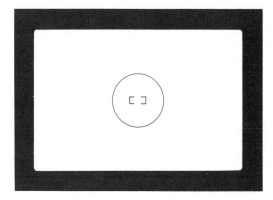

The viewfinder of the EOS 650 with the most important metering areas outlined. The circle indicates the area for partial metering and the small rectangle the area for autofocusing.

one with partial metering. This before-and-after effect will definitely be appreciated by the slide photographer. Those of you who are using colour print film may not be able to discern much difference as these fine nuances are often lost in the processing lab. This has nothing to do with the quality of processing in large labs, rather with the method of processing. As this is done by an automatic process, the machine will compensate for "deviations"; in fact it is programmed to produce an average acceptable result in the two-stage process of developing and printing. The slide process, on the other hand, does not add or subtract anything to that which you have exposed onto the film. Slide photography is therefore the best testing point for partial metering and the first step in the higher school of creative photography. The EOS will open up the paths to excellent results in astonishingly simple fashion.

Only after you are more familiar with the intricacies of partial metering should you try another form of photographer-determined exposure control: exposure compensation.

The Case of the Plus and the Minus

If the Canon designers had not always had the demands of the

discerning and creative amateur photographer in mind, then they would have dispensed with a number of details in their camera brief. The possibility of manual exposure compensation would have certainly not been included or it would have been placed at a less conspicuous position amongst the operating elements. Let me state clearly: this is no exposure program but a corrective measure that is possible in all shooting modes with the exception of the full auto mode. The button is called exposure compensation and it allows for over- or underexposure by up to 5 f/stops relative to the metered value. When this button on the left-hand shoulder of the camera is depressed then 0.0 and +/- appears in the display panel. Keeping the button depressed and turning the input dial anti-clockwise selects minus corrections, turning it clockwise selects plus corrections. The exposure compensation is performed in half stops, producing a very exact, finely-dosed exposure correction.

I have talked a lot about the excellent metering facilities of the EOS. There is the evaluative metering system and if this is insufficient, there is partial metering. What is the point in including an exposure compensation facility? Well the case when this is useful arises rather more often than you may think. This has nothing to do with the camera, rather with the variety of ways light and shade and subject contrasts are presented to the camera. Let's take two examples to illustrate the point. If we put a black horse in an Alpine snowscape, then its presence will be rather small in the expansive white landscape. Depending on relative size, even partial metering may not produce correct results. The camera's metering would take the predominant white snowscape as the decisive factor in determining the exposure value. Result: a rather blacker than black, i.e. underexposed blob, no longer distinguishable at all. This electronic misconception may be corrected only by manual override, by opening the aperture by one or even two stops. The same applies in the opposite case. A dominant dark area and a proportionally rather small main subject with very light tones. This could be the case in stage

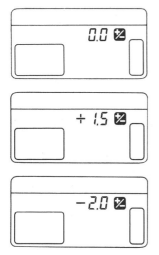

Display panel symbols for manual exposure corrections. Top: normal setting (without correction). Centre: an exposure correction of +1.5 stops has been selected. Bottom: an underexposure of 2 stops has been selected.

photography with its relatively high contrasts. Here too, the experienced eye will be able to decide corrective measures in the minus direction. These plus and minus corrections could be of decisive value for the final result. Moody backlit scenes could be enhanced to a silhouette-type image by a rather short exposure or, on the other hand, the main subject could be shown with good detail against an overexposed, paled-into-insignificance, background.

Then there is a whole range of specialities. Experts talk of "high-key"; i.e. an intentional and precisely-measured over-exposure, and "low-key"; an intentional and precisely measured underexposure. The high-key effect was quite fashionable for some time in depicting the gentler sex with delicate effect. A light background, soft but intense illumin-ation, and appropriate overexposure, produced portraits with the delicate touch. The so-called stronger sex, on the other hand, was depicted by the photographer in a sharply defined, hard light, against a dark background and with effective under-exposure so emphasising strong lines and hard, strong

contours. I have caricatured the tricks of the portrait photographer here as trashy. Even so, we can learn from these tricks and use them for our own considered effects, not only for portraits but for many other subjects. Remember though, if you leave the well-tried path of automatic exposure evaluation and experiment with manually-assessed values, you will need good sense and some experience. But don't be discouraged, experiment away!

Self-timer — the Modern Version.

You will look in vain for the good old self-timer. But don't worry, it is there, but in a modern disguise, what else? The EOS designers have hidden it behind the flap on the lower rear of the camera body. It is the little blue button which is also used to select between "S" for single shot and "C" for continuous shooting. Next to this button is another symbol which may be deciphered with some imagination as a clock dial. Setting is quite simple. Depress the blue button and turn the input dial until the clock symbol appears in the little window on the right-hand side of the display panel. After depressing the release a red light at the front of the camera begins to blink rapidly. This means that the self-timer has started the count-down. The total time before releasing is 10 seconds. Two seconds before the shutter is released the light blinks more rapidly. Should you wish to interrupt the self-timer sequence because it was activated by mistake, or for some other reason, you simply depress the battery check button and the sequence will be terminated.

You may think that you will never make use of this facility.

EOS programming: program mode and focus priority.

Reason: with justifiable confidence in the autofocus system of the EOS, even under poor lighting conditions, the focus priority was kept activated for this shot. Moreover, the exposure program indicates that it will select shake-free shutter speed/aperture combinations under almost any conceivable circumstances. In this case, however, the use of a quite fast film (ISO 400/27°) was necessary. Photo: Karl Forster

Most photographers are not particularly interested in including themselves in that little group shot at the picnic or wherever. The self-timer has other uses. It can be used for a particularly shake-free triggering of the shutter. If the camera is on a tripod and you are giving a long exposure, then the self-timer is often the ideal way; it means you cannot shake the camera at the moment you depress the release button. Used in this fashion the self-timer replaces the cable release.

Long Exposures

Exposure times of up to 30 seconds are automatically controlled. However, there are situations where even this time would be insufficient. Let's take, for example, astro photography and trick shots with long exposures. The EOS has suitable facilities to cope with this situation. Set the exposure mode to M, turn the input dial until "bulb" appears in the display panel — this is the next value after 30 seconds. Depress and keep depressed the manual aperture set button and turn the input dial to select the required aperture. The camera uses relatively little current in the long exposure program which is good news for your battery power. The count down of the exposure is displayed in the display panel by a sequence of three bar symbols and the numbers 1 to 30. Each bar symbol indicates a period of 30 seconds. The total long exposure possible is therefore 120 seconds: three bar symbols plus 30 seconds. In the bulb setting the shutter remains open, as long as you keep the shutter button depressed. I suppose, you will use these long times only rarely, but if you do, the EOS will meet your requirements.

Autofocus, Always Certain?

When bestowing so much praise on a camera one has to be fair and also mention its limitations. The autofocus works perfectly — within certain limits, that is. After all, it is a machine and not a human, capable of intelligent assessment. In any case it is astonishing how intelligent it is and at what low lighting levels it functions. There are three types of subject however where the autofocus cannot cope:-

○ Where there is little contrast, for example a foggy land-scape, and subjects with only darker and lighter patches but no distinct outlines. A snowscape could present such a problem to the autofocus because it may try in vain to find a suitable point to focus on. Presented with such a subject I would not bother the camera unnecessarily but switch over to manual focusing on the lens, i.e. from AF to M.

○ An extremely poorly lit subject, a dark room or a night shot. Below a certain level even the "power eye" will be powerless. The EOS is much more powerful in this respect than most of its competitors, but it is no night owl either.

○ Subjects with predominantly horizontal patterns. An example would be a venetian blind.

The autofocus could also be confused by extreme backlit shots with hard reflections. An example would be when the sun is reflected from a water surface. Here too you may have to resort to manual focusing.

There is another situation where the photographer's guiding hand is required. Let's say you wish to get a shot of a monkey behind bars: the autofocus will naturally assume that the closer bars are the important details and not the monkey grooming himself at the back of the cage.

I have praised the speed at which the autofocus works. However, if the scene is confusing, containing rapidly moving details, then the autofocus will also be confused. The reason is that such jumpy subjects may be difficult to keep in the

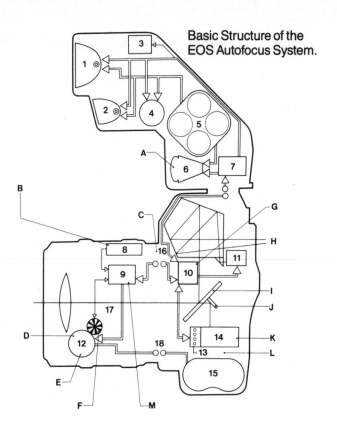

Basic Structure of the EOS Autofocus System.

1	Flash reflector	
2	Infra-red metering flash	
3	LCD monitor	
4	Zoom reflector monitor	
5	Battery compartment	
6	Infra-red metering flash for AF	
7	Flash microprocessor	
8	Zoom information	
9	Lens microprocessor	
10	Main microprocessor	
11	Display	
12	AFD or USM	
13	BASIS	
14	Optical system (AF)	
15	Batteries	

16 Electronic contacts (for data transfer and power supply)
17 Lens position information
18 Power supply
A Functiions automatically with exceedingly bright LED for subjects in the dark
B Focal length information (zoom button)
C Transfer
D Autofocus control motor
E Ultrasonic motor for autofocus

F Impulse disc (to meter the drive force)
G Autofocus focusing memory and control. Signal output for lens control
H Display for set values
I Partially translucent main mirror
J Auxiliary mirror
K Unit for AF control
L Line sensor for automatic distance metering
M Data transfer, lens control, auto-control.

metering rectangle long enough to get a good focus. I don't think you will encounter situations such as these very often however.

The "BASIS" for the automatic focusing of the new EF lenses for the EOS system is in the camera. This is a tiny, 48-bit line sensor chip with amplifier circuits in an integrated LSI. The design is logical and clear, accommodated in one unit. Canon called it BASIS. These five letters are the initials of "Base Stored Image Sensor". This system has a better response, a better signal-noise ratio and is more capable of reading incoming signals than the CCD and MOS line sensors used in other camera systems.

The basic principle of automatic distance metering in the

Some examples of subjects that are difficult for the autofocus mechanism: A — subjects with poor contrast; B — subjects under particularly poor lighting conditions; C — subjects with mainly horizontal structures; D — subjects with confusing elements in the foreground.

EOS 650 is fairly similar to systems offered by other manufacturers. Canon also use the so-called TTL-SIR method (Through-The-Lens Secondary-Image-Registration). This is also sometimes referred to as the phase detection method and has proved the better system compared with infra-red and ultrasonic metering, mainly because these systems are limited in their range which make them unsuitable for telephoto lenses. The only handicap of the TTL-SIR system is that it is dependent on a certain amount of illumination and sufficient and suitable subject contrast. The development of the new BASIS-sensors in preference to the previously-used CCD and MOS sensors could overcome these weaknesses to some extent. The automatic focus is capable of working under lighting conditions appropriate to aperture f/1.4 and 1 second exposure time. This improvement was made possible through

This is the "core" of the EOS technology. BASIS — the autofocus metering sensor. Despite its enormous capacity it is tiny in size, 1.44x0.15mm to be exact.

the early amplification of the image signal and an improvement in the separation of the signal from the noise patterns. To date the BASIS line sensors are only used as line sensors for automatic distance metering. Because of their excellent characteristics Canon intend to also use this system in image sensors for a future development of video images with extremely high resolution.

The metering data from the AF system is immediately transferred to the central microprocessor where it is processed and finally transferred via the bayonet contacts to the microprocessor in the lens. The latter draws the necessary conclusions and directs the motor to adjust the focus on the lens to obtain sharp focus. The exchange of data always keeps the central processor informed as to what lens has been attached, even for zoom lenses the setting on the lens is always known to the central "brain".

All About "POWER EYE"

Before I discuss individual focal lengths in more detail I should like to talk about some aspects that are common to all types of lenses. The Canon autofocus lenses are no heavier than conventional, manually-focused lenses, despite the fact that there is a lot of technology packed into their mounts. To start

"X-ray view" through an EOS lens with all electronic and mechanical transfer elements.

with there are the different, motors for automatic focusing. Unlike other manufacturers, Canon have decided to place the motor drive in the lens — the logical position — and not in the camera. The motor is close to the point where it is required, with consequent advantages. The most obvious being that any mechanical coupling between camera and lens is superfluous. The second advantage lies in the fact that all sorts of accessories, such as extension rings or bellows may be placed between camera and lens, without interfering with the autofocus function. The third and most important advantage lies in the possibility of being able to adjust the output of the motor to the exact requirements of the particular lens. There are no mechanical transmission elements in the new Canon EF lenses. All control functions are performed by electronic data transfer. This was the reason for developing the new electronic bayonet.

The Electronic Bayonet

By introducing the new EOS system Canon broke with a 29-year old tradition. They introduced the electronic bayonet, which will not accommodate any of the old manually focused lenses. This break with the old system gave the opportunity to redesign the lens program, with new advantages. The diameter of the new bayonet has been increased to 54mm and the flange focal length, that is the distance between bayonet plane and film plane, was chosen as 44mm. The change of these dimensions was necessary to accommodate the new, superfast Canon EF f/1.0, 50mm L standard lens, the fastest standard lens for a reflex camera on the market at present. Furthermore, the change of the bayonet dimensions should facilitate a 100% viewfinder viewing area in future EOS models. Another advantage is that the mirror and viewfinder will not interfere with even extremely long lenses.

The lens bayonet is fashioned of high grade steel. The entire data transfer between camera and lens is by electronic methods, via the eight gold contacts on the camera bayonet and the seven contacts on the lens bayonet. The contact area is by

EOS programming: aperture priority, AF lock and plus correction.

Reason: aperture f/16 was preselected to obtain the necessary depth of field. To ensure that the foreground was in sharp focus, the AF mechanism was first pointed at the curtain, the result retained in AF lock, then the camera was realigned to the required frame. To correct for underexposure of the foreground a manual exposure compensation of plus one stop was necessary. Photo: Karl Forster

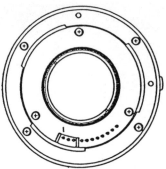

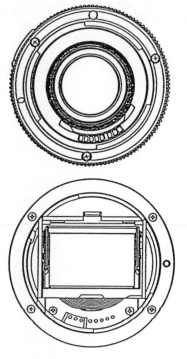

Top left: bayonet of the EF 50mm f/1.8 lens
Top right: bayonet of the EF tele extender 2X
Left: bayonet on the camera housing.

two-stage structure for greater safety, ensuring safe contact transfer under minimal physical contact with the lens. The Tele-Extender 2X and the EF intermediate ring have another three contacts on the lens side, which inform the lens of their presence. On the camera side these accessories have eight

EOS programming: shutter speed priority with release priority (top), with focus priority and AF lock (bottom).

Reason: for moving subjects it is usually better to switch off the AF facility because the camera may not release the shutter if it thinks that the correct focus has not been obtained. For the game with selective depth of field the gondola had to be focused in the centre of the frame first; then, keeping the setting with AF lock, the frame was realigned for the required picture.

Photo: Hermann Groeneveld

contacts, which transfer all data to the microprocessor in the camera. The lens informs the camera about its function, i.e. either AF or M mode, type of lens, largest and smallest aperture opening, present distance setting, focal length and type of autofocus drive.

The lens takes its power supply from the camera. This has been subdivided into two areas to ensure greatest possible operational safety. The autofocus and aperture motors in the lens, requiring more power, were separated from the power supply for the lens' electronics.

Electro-Magnetic Aperture Control — "EMD"

You will look in vain for the aperture ring for manual adjustment of the aperture. In the new EOS lenses the aperture value is

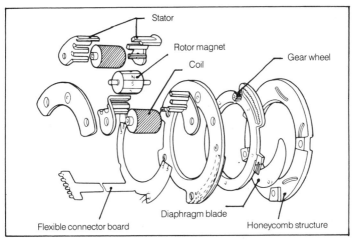

Exploded view of the structural elements of the EMD — electro magnetic diaphragm.

EOS programming: shutter speed mode with release priority.

Reason: a moving subject, therefore as fast a shutter as possible, disregarding loss in depth of field. When and where the AF facility should have priority with the EOS is a matter of opinion. In case of doubt switch to release priority when shooting moving subjects. Photo: Hermann Groeneveld

71

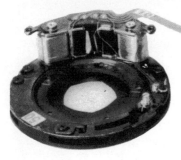

The mechanism of the EMD

controlled electronically via the microprocessor. A stepping motor in the lens tube is the heart of the unique diaphragm mechanism of the EOS 650. The basic structure is similar to the mechanism of conventionally adjusted apertures. The electronically controlled stepping motor ensures particularly precise control of the aperture. The aperture blades that form the opening and their control mechanism in the lens could be combined to a fixed unit, no longer requiring a lever. Not only is its function extraordinarily precise, it is also very quiet in its function. The only moving parts are the bearings, which makes this type of drive particularly robust and reliable. The arch-shaped arrangement of aperture control elements around the aperture allowed the traditional shape of the lens to be retained. The aperture blades are closed and opened via a geared wheel of the stepping motor in one-eighths stops.

Autofocus Motor Type "AFD"
Ten of the thirteen new Canon EF lenses have the newly developed arch-type AFD motor for automatic focusing. The three letters are the initials for Arc Form Drive. This is a type of improved, brushless Hall motor which is built directly into the lens tube. Because of its shape it fits perfectly and neatly inside the round lens shape and these new EF lenses therefore look exactly like conventional lenses. The power is transferred to the focusing mechanism by motor via a two-gear drive. The motor moves the focusing element in the lens along the optical

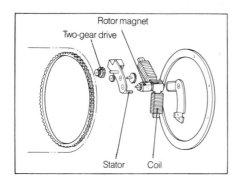

The drive mechanism of the motor is arch-shaped. This allows electronic control of the elements in the lens without having to change the conventional appearance of the unit.

axis by spiral or control disc. Because the motor is placed close to the driven parts, its function is relatively quiet. The small diameter of the driving motor makes it particularly fast. This type of drive can be easily adjusted to the given lens characteristics.

Autofocus Motor Type "USM"

The real "piéce de résistance" is the drive installed in the three top class Canon lenses: the UltraSonic Motor. This drive works with piezoelectric ceramic elements with separate polarities which are attached to a ring and drive a motor by their vibrations. An alternating current with resonant frequency causes the piezoelectric elements to either expand or contract according to their specific polarity. The resultant bending vibration drives the vibrator. The vibration reverts back to a wave motion through the renewed effect of the resonant frequency after moving through a 90° phase, which, in turn, drives the motor. The motor moves the focusing element via a spiral or a control disc along the optical axis until focusing has been achieved.

The arched shape of the motor fits neatly into the conventional lens shape and is easily adaptable to the individual requirements of the given lens. As the drive is located close to

Rotor Vibrator
Piezoelectric element
Damper Washer
Flat spring

Piezoelectric elements

Resonant frequency

Diagrammatic view of an
"UMS" (ultrasonic
motor), considered to be
a marvel of modern
technology.

the driven parts its efficiency could be optimized. The instant
and precise reaction in the start-up and stop phase allows
super-exact focusing; further advantages are low noise levels
and extreme compactness. The "USM" lenses will be
particularly appreciated by animal photographers who so far
were very sceptical of autofocus because of the comparatively
noisy mechanism.

UD-Glass and Moulded Aspherical Lenses
The new EF lenses are not only technically but also optically at
the forefront of developments. The use of so-called UD-glass
in many lens types ensures improved contrast rendition,
higher resolution and exceedingly brilliant colours. Aspherical

elements correct aberrations and give a much better performance. New processes simplified the manufacture of aspherical elements. Canon was thus able to incorporate these types of elements in more of their lenses. The previous complicated grinding process is now replaced by a moulding process which is cheaper and easier to control. Canon incorporated these elements in four of the new EF lenses. These moulded aspherical elements are different from conventional lenses with the usual curved shape — they have more than one curvature which counteracts distortions and aberrations. The introduction of this type of elements in the next generation of zoom lenses will lead to better lens performance despite increased focal lengths and more compact construction.

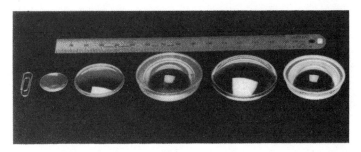

Moulded aspherical elements used in EOS lenses.

Canon EF Lenses — A Complete Range

The right perspective is the most important thing — in photography as in life generally. Looking at life in all its manifestations from the right angle tends to bring about a better result, or in terms of photography a better picture. One of the great advantages of an SLR camera is that one is able to change the lens and thus the manner in which the subject is viewed without changing one's position, or the other way round, by changing one's viewpoint.

Interchangeable lenses allow the photographer to determine exactly the angle of view and thus the framing, i.e. he shows only what he wishes to put into the picture. The longer the focal length of a lens, the larger far-off subjects can be made in the frame. Shorter focal lengths, on the other hand, show the entirety of large objects or compress large expanses into the 35mm frame, even when viewed from fairly close range. A zoom lens changes the frame continuously from the shortest to the longest focal length without having to change the lens or the viewing position. Special lenses allow large-scale representation of even the tiniest subjects, others show portraits and other subjects in flattering soft focus.

Canon offers the customer a large range of lenses for every conceivable application in the manual focusing range. These lenses are renowned for their excellent quality and versatility. For this reason Canon introduced not only a new camera with some essential basic lenses, but a whole range of system lenses, that, no doubt, will be extended in the future. In keeping with their previous principles, the design of interchangeable EF lenses for the EOS is also based on versatility

EOS programming: DEPTH mode (top) and program mode (bottom).

Reason: a subject such as this with a rocky landscape and a building in the background is literally begging for the greatest possible depth of field. The snapshot at the bottom was easy in fully automatic shooting mode.　　　　　　Photo: Jürgen Schoenwiese

and quality. For this reason each lens is equipped with a suitable motor, always considering how many elements have to be moved and by how far. All lenses in the EF program may also be focused manually. They are equipped with a slide switch for this purpose which couples the manual focusing ring with the focusing mechanism. Compared with the manual lenses Canon were able to improve the new Canon EF lenses with regard to lens speed because of the new bayonet. The reproduction quality was also improved by the use of new glass types and lens shapes. The launch of the EOS 650 was accompanied by the introduction of a total of thirteen lenses. Focal lengths range from the 15mm fisheye lens to the super fast 300mm telephoto lens which may be extended to 600mm by the use of a special extender. Four of the range bear a red ring and an "L" in their type code, this is the sign of special quality, as in the previous range of Canon lenses. The construction of these L lenses includes so-called UD glasses with particularly low dispersion and aspherical elements to correct aberrations.

A New Standard for Standard Lenses

Lenses whose focal length corresponds to the diagonal of the frame are generally referred to as standard lenses. This corresponds to focal lengths between 40-50mm for the negative format of a 35mm camera. An advantage of the standard lens for most makes and constructions is its high lens speed. The new EF 50mm f/1.0 L is a special little gem amongst even the best. This extremely high lens speed could be achieved by the use of these special glasses and aspherical elements. Most standard lenses are very compact and light; compared with these the new EF f/1.0 50mm is quite bulky. Weighing in at 960g it is 240g heavier than the 100-300mm zoom, the longest zoom lens in the present Canon EF program. Its length too substantially exceeds that of many zoom lenses. For this reason it will appeal mainly to specialist night photographers. The integrated USM ultrasonic motor works almost sound-

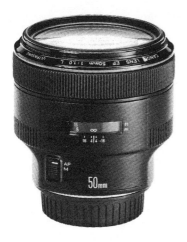

lessly. Manual focusing is done via electronic coupling with the USM motor which may be operated as easily as any conventional lens.

The construction of this amazing lens employs eleven elements in nine groups. It is Canon's answer to the question of usefulness of the standard lens. The modern trend is towards wide-angle zooms that include the standard focal length. But if you are interested in an atmospheric picture of a twilight or candle-lit scene, then the only answer is a high-resolution film and a fast lens. This lens is not only extraordinarily fast, its reproduction quality and resolution is of a particularly high standard. Two aspherical elements ensure the high perform-ance even at full aperture. The use of glasses with extremely high refractive indices, together with the newly developed multi-layer coating, contribute to the enhanced reproduction quality.

The second of the Canon standard lenses, the 50mm f/1.8, weighs only one fifth of its big brother. This is the lightest and most compact lens in the range and has the fastest speed after the EF 50mm f/1.0 L. In keeping with its more compact con-struction it has a smaller filter diameter and may be stopped down to f/22. However, the real advantage of the standard lens

Canon EF Standard Lenses

	EF 50mm f/1.0 Lu2	EF 50mmf/1.8
Focusing motor	USM	AFD
Angle of view	46°	46°
Elements/groups	II/9	6/5
Smallest aperture	f/16	f/22
Closest focusing distance	60cm	45cm
Filter diameter	72mm	52mm
Length	80.0mm	42.5mm
Weight	960g	190g

is its relatively large widest aperture together with excellent reproduction even at the largest opening. The equivalent in the EF range of the already excellent FD 50mm f/1.8 in the manual range could be improved upon; its contrast transfer is better,

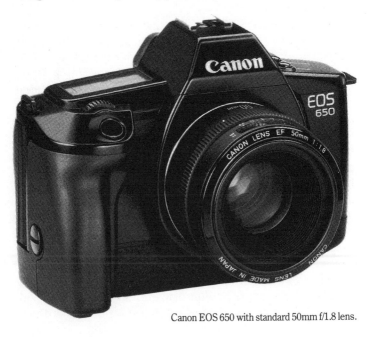

Canon EOS 650 with standard 50mm f/1.8 lens.

its colour reproduction was brought into line with international standards and the close-up range could be reduced by 15cm compared with the FD lens. This lens needs less than half a second for automatic focusing, covering the entire focusing range from 45cm to infinity. All photographers who dislike flash and prefer available lighting under almost any circumstances will definitely decide on one of these lenses.

The Unusual Perspective with Fisheye and Wide-Angle Lenses

The Canon Fisheye EF 15mm f/2.8 shows the entire panorama in front of the camera, covering a angle of view of 180°. This unusual focal length is particularly suitable for dramatic landscapes. Despite the large angle of view this lens will cover the entire frame and not only the usual circular section. However, the price for this large angle of view are converging lines that are particularly noticeable towards the edge of the frame. Compared to the previous generation of FD lenses, this effect could be considerably improved. Even so, landscapes taken with the fisheye lens are easily identifiable by the curved horizon and buildings and interior shots, by the typical curvature of lines at the edge of the frame. The high lens speed of f/2.8 is particularly noteworthy with this lens, also its compactness. It measures a little more than 60mm and weighs only 365g. The compact construction is due to a more economical design using fewer elements and, despite the reduction in elements, it has better performance.

A slide-in compartment in the tube of this lens will accommodate any filter. You may use any normal, unmounted gelatine filter. However, it is not possible to use a combination of filters as the compartment is designed to take only one.

The new Canon EF 28mm f/2.8 lens is almost totally free of any distortion. Despite its high speed it is very light; together with the EF 50mm f/1.8 it is the most compact and lightest lens of the new EF range. Its compact construction was possible by

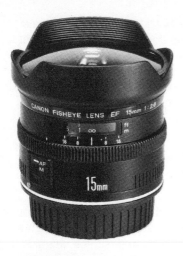
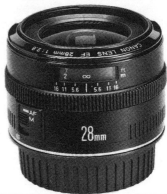

Left: Canon Fisheye EF 15mm f/2.8.
Right: Canon Wide-angle EF 28mm f/2.8.

the use of the new moulded aspherical lenses. This lens is particularly useful for available-light photography in restricted spaces, such as churches, museums, etc, everywhere where you need a wide angle of view and cannot use flash. Because of its great depth of field it is also very suitable for snapshots and space-embracing landscapes. Compared with the wide-angle zooms which also include this focal length, the fixed focal length lens has the advantage of greater speed and smaller minimum focusing distance. The fixed focal length wide-angle

Canon EF Wide-angle Lenses

	Fisheye EF 15mm f/2.8	Wide-angle EF 28mm f/2.8
Focusing motor	AFD	AFD
Angle of view	180°	75°
Elements/groups	8/7	5/5
Smallest aperture	f/22	f/22
Closest focusing distance	0.2m	0.3m
Filter diameter	Filter holder	52mm
Length	62.2mm	42.5mm
Weight	360g	185g

lens can be taken as close as 30cm to the subject, compared
with the two wide-angle zoom lenses that embrace this focal
length which allow close-up ranges of 50cm and 75cm
respectively.

The Lens for Romantics

The Canon EF 135mm f/2.8 soft focus lens is a speciality lens in
the Canon EOS program. It is really two lenses in one mount.
On the one hand it is a really handy, fast telephoto lens with a
very popular 135mm focal length, producing excellent quality
pictures of perfect sharpness and good contrast in its normal
use. In addition it has a variable soft focus function which is an
effect produced by spherical aberration. It produces a soft
diffusion which lends these pictures a romantic, impressionist
quality. If you are after the portrait with an ethereal look, where
any unflattering blemishes are hidden beneath a dreamy veil,
then you will delight in this lens. The soft focus ring has three
positions, without, with slight, and with maximum soft effect.
The photographer no longer needs to carry little gadgets such

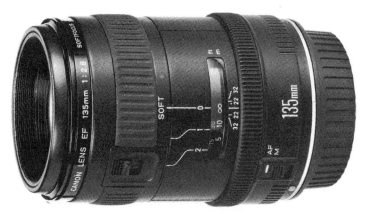

Canon EF 135mm f/2.8 soft focus lens.

as silk stockings, cumbersome filters or any other little tricks of the trade such as Vaseline or breathing on the front element to achieve this effect. The soft focus effect increases with increased aperture opening. Another advantage of the large aperture is to be able to blur into insignificance any disturbing backgrounds. The uses of this special lens are greater than a first glance may suggest, from portraits via nudes to the romantic landscape and still-life with a special note. The soft focus makes the subject appear as seen through a thin veil, lending it a mysterious and unreal aspect.

Canon EF Soft Focus Lens

	Canon EF 135mm f/2.8 Soft Focus
Focusing motor	AFD
Angle of view	18°
Elements/groups	7/6
Smallest aperture	f/32
Closest focusing distance	1.3m
Filter diameter	52mm
Length	98.7mm
Weight	410g

Superfast Telephoto for Highest Demands

The Canon EF 300mm f/2.8 L may justly be described as a lens in a class of its own. This superfast telephoto lens will find an enthusiastic welcome especially amongst sports photographers where the ability to catch fast actions on the other side of the track, above the heads of the crowds, etc. is of the utmost importance. The high speed alone is argument enough for this type of photography, also for animal photography in low available lighting. It goes without saying that this super tele

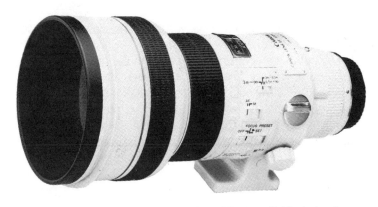

Canon EF 300mm f/2.8 L telephoto lens.

Canon Extender EF 2X

lens is equipped with the nearly noiseless USM motor for autofocus setting. The use of UD glasses reduces to a large degree any chromatic aberrations that telephoto lenses in particular suffer from, making this not only an exceedingly fast, but also qualitatively excellent lens even at full aperture. The extender specially designed for this lens will extend the focal length to 600mm without adversely affecting the picture quality; only the lens speed will be reduced. Even so, this still results in an excellent 600mm super-telephoto lens with a speed of f/8. At the moment this converter can only be used with this telephoto lens, but it is intended that other telephoto

lenses to be introduced in the future will be suitable for use with this extender.

The automatic focusing function from the shortest setting distance to infinity takes only 0.42 seconds. The focusing speed of the ultrasonic motor can be increased by presetting the subject distance on the lens. The photographer can manually set the approximate distance of the subject, i.e. for distances between 3m and 6.5m or from 6.5m to infinity. The lens therefore need not traverse the entire setting distance from 3m to infinity to find the focusing point. This method is useful for sports photographers who will know where to expect their subject. A special filter holder at the end of the lens is provided. Filters are part of this lens' optical construction and are always needed. The filter diameter is 48mm.

Manual focusing is provided by the focusing ring and electronic coupling to the focusing motor. The focusing speed is adjustable in three stages. The normal speed corresponds to

Canon EF Telephoto Lens and Extender

	EF 300mm f/2.8 L	Extender EF 2X
Focusing motor	USM	
Angle of view	8° 15 sec	
Elements/groups	9/7	7/5
Smallest aperture	f/22	
Closest focusing distance	3m	
Filter diameter	48mm	
Length	243mm	50mm
Weight	2850g	290g

EOS programming: aperture priority, AF priority plus correction.

Reason: a small aperture was preselected to obtain a large depth of field. The AF priority was useful because the AF mechanism had a clear focusing point on the fence in the snow covered landscape. The exposure had to be corrected by one aperture stop in the plus direction — as is usual with snowscapes, particularly if they are backlit. This was done by manual exposure compensation.

Photo: Klaus Lipa

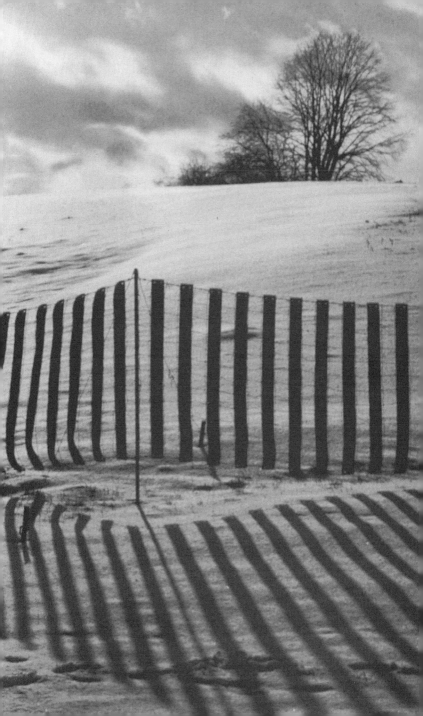

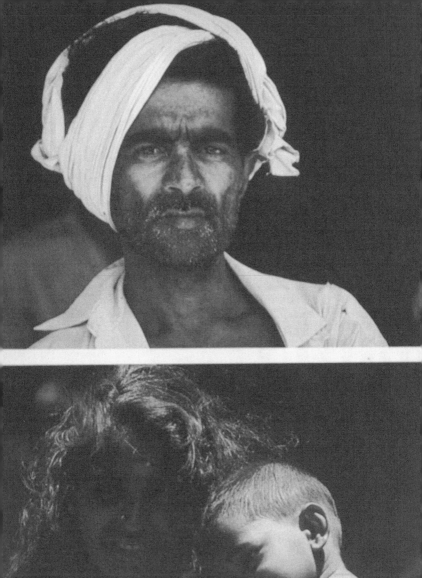

about the mechanical transmission on a conventional FD lens of similar construction. The focusing speed may be reduced to half or doubled.

Variable Focal Lengths from Wide-Angle to Portrait Telephoto

Canon covers the popular range from wide-angle to portrait telephoto with four different zoom lenses with between double to three times the fixed focal length. Before buying you should consider very carefully what you photograph most often and what equipment you will need for your most frequently-covered subjects. The top of the class of the zoom lenses offered in this range is the Canon EF 28-80mm f/2.8-4.0 L. The "L" in the model description and the red ring on the lens

Canon wide-angle EF 28-70mm, f/3.5-4.5 zoom lens.

EOS programming: aperture priority and partial metering with release priority.

Reason: such critical subjects with high contrasts are better metered in partial metering mode. The autofocus would have functioned perfectly well in this situation; the release priority, however, is safer for a quick snapshot. A fill-in flash would have been the best solution in these situations: it could have can be done with fully automatic ease by the EOS System. Photo: Klaus Lipa

Canon wide-angle EF 28-80mm, f/2.8-4.0 L lens.

indicates that this is a lens for the highest requirements. Its reproduction quality is comparable to any fixed focus lens in this range. The use of special glasses for best reproduction quality and the quiet USM motor, together with the relatively large widest opening are all characteristics of a top quality lens. Two aspherical elements ensure high quality throughout the entire focal length range. Floating elements correct aberrations for all distance settings, eliminating distortions across the whole range. Curvature of field and chromatic aberrations in the telephoto range could be suppressed to a high degree. A nearest focusing distance of 40cm is possible over the entire

Canon wide-angle EF 35-70mm, f/3.5-4.5 zoom lens.

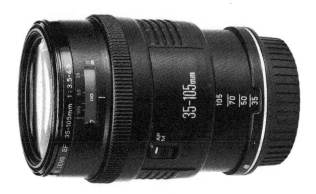

Canon wide-angle EF 35-105mm, f/3.5-4.5 zoom lens.

focusing range. The only price you have to pay, apart from the financial one of course, is the greater weight and bulk.

The EF 28-70mm f/3.5-4.5 is 10mm shorter in its focal range, weighs less than a third of its heavy brother in the L class, and it is also 4cm shorter. This lens is aimed as a compact and reasonably-priced zoom to a wide group of photographers. The compact construction is possible by the use of moulded aspherical elements, and the length of the tube remains unchanged with changing focal length setting. Changing of focal length is by turning the zoom ring.

The 35-70mm f/3.5-4.5 may be described as a real lightweight at only 300g. Photographers who find that they can manage with the speed of this lens will also find it a delight to use in every other respect. It is very handy as it is not much heavier or bulkier than a standard lens. Also, its compact size does not change with varying focal length, due to its special construction. And, just like other Canon zoom lenses, it has a special macro setting for format-filling views of small objects. The closest focusing distance is 50cm, which is the same throughout the entire focal length range. The 35-70mm zoom is also a rotating ring zoom.

Physically the shortest lens in the world at the time of writing is the Canon EF 35-105mm f/3.5-4.5 zoom. As with the other

Canon Tele-zooms for the EOS, the focal length is adjusted by a rotating ring, but in this case the length of the tube will vary with changing focal length. Despite the wide range of focal lengths, covering three fixed lengths, it is exceedingly compact due to the use of moulded aspherical elements, giving excellent reproduction quality. Because of its lightness it is the ideal companion on journeys and it is also ideally suited for snapshots, even allowing format-filling portraits from a distance and atmospheric "having been there" intimate shots in bustling crowds and all-embracing shots with the shorter focal lengths. In macro mode, which is available over the entire zoom range, you can move to within 85cm of the subject. As it is

Canon EF Wide-angle Zoom Lenses

	EF 28-70mm f/3.5-4.5	EF 28-80mm f/2.8-4.0 L
Focusing motor	AFD	USM
Angle of view	75-34°	75-30°
Elements/groups	10/9	16/12
Smallest aperture	f/22-f/29	f/22-f/32
Closest focusing distance	0.5m	0.75m
Filter diameter	52mm	72mm
Length	74.8mm	122mm
Weight	300g	940g

Canon EF Wide-angle Zoom Lenses

	EF 35-70mm f/3.5-4.5	EF 35-105mm f/3.5-4.5
Focusing motor	AFD	AFD
Angle of view	63 -34°	63 -23° 30sec
Elements/groups	9/8	14/11
Smallest aperture	f/22-f/29	f/22-f/29
Closest focusing distance	0.5m	1.2m
Filter diameter	58mm	58mm
Length	63mm	81.9mm
Weight	245g	400g

so light, many photographers will choose to keep this lens as the universal lens on their camera at all times.

Long Focal Lengths — Short Lenses

Canon managed to surprise us most pleasantly with the construction of the new telephoto zoom lenses. Weighing only 650 or 720 grammes, the three new lenses for distant subjects belong to the lightweight class despite integrated autofocus and aperture motors. All three are constructed as slide zooms i.e. the focal length is adjusted by sliding the zoom ring. Two of these lenses have almost identical specifications. The 100-300mm zoom lens is available as standard and as an L model. Externally the difference is indicated by the red ring and the L in the type code. Comparing weight and lens speed, the two are more or less identical, although the "luxury class" zoom has one more element in its construction and is 0.2mm shorter than its slightly cheaper brother. In their optical construction the two lenses correspond to their forerunners in the FD system with manual focusing. The improvement lies in the close-up area over the entire zoom range, which can be reduced to 1.4m. The better reproduction quality of the L lens is due to the use of fluoride and UD glasses to correct chromatic aberrations.

The third in this range, the 70-210mm zoom lens, is a whole stop faster, weighs 70g less than its two longer brothers and is also shorter by 3cm. The greater compactness compared with the conventional manually-focused lens of the same specification was achieved by reducing the construction by one element. The excellent reproduction quality is due to the use of an aspherical element.

The question of which tele zoom lens to choose is best answered by what subjects you are likely to hunt. No doubt the price will also play a part. We are not all lucky enough to be able to afford a high performance lens such as the EF 100-300mm f/5.6 L. The high quality of this lens will be appreciated by those

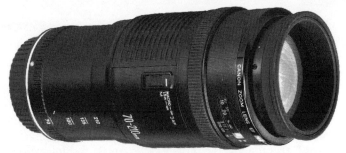

EF 70-210mm f/4.0

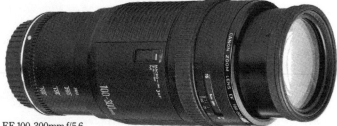

EF 100-300mm f/5.6

EF 100-300mm f/5.6 L

of you who wish to enlarge their shots to very large formats or who make the greatest demands on the quality of large slide projections. On the other hand you have to be careful that the high picture quality produced by a good lens is not spoilt by the use of inferior film material or by poor development and printing in the lab. It is essential to take care that the excellent quality that the lens is capable of projecting onto the film is not

ruined by that one weak link in the chain of producing the final result. Possessing and using excellent camera equipment implies the same care and attention to choice and handling of the film.

Canon EF Telephoto Zoom Lenses

EF 70-210 mm f/4.0	
Focusing motor	AFD
Angle of view	34-11° 45 sec
Elements/groups	11/8
Smallest aperture	f/32
Closest focusing distance	1.5m
Filter diameter	58mm
Length	137.6mm
Weight	650g

Canon EF Telephoto Zoom Lenses

	EF 100-300mm f/5.6	EF 100-300mm f/5.6 L
Focusing motor	AFD	AFD
Angle of view	24-8° 15 sec	24-8° 15 sec
Elements/groups	15/9	15/10
Smallest aperture	f/32	f/32
Closest focusing distance	2m	2m
Filter diameter	58mm	58mm
Length	166.8mm	166.6mm
Weight	720g	720g

View to the Future

The EOS program, pointing to the future and more developments, already comprises thirteen lenses, but this is not the end. Several projects are already in the development stage and will soon be put into production. Four further zoom lenses and one macro lens will be added to the range of system lenses in the near future.

The macro lens with a focal length of 50mm falls into the range of standard lenses. It has a relatively high speed of f/2.5 and, although it had been designed for the close range and reproduction scale down to 1:2, it also possesses excellent reproduction qualities in the range to infinity.

A special intermediate ring was developed for this lens, increasing the reproduction scale to 1:1. The use of floating elements ensures uniformly excellent reproduction quality at all shooting distances. The large initial aperture opening allows the subject to be emphasised against a blurred background because of the shallow depth of field.

In the design stage are two more zoom lenses covering four focal lengths, namely 50 to 200mm. Similar to the 100-300mm zoom, this range will also be covered by a standard and a luxury version. These very useful zoom lenses from the standard to the telephoto range will be very compact and both will have a close-up focusing setting across the entire focal length range, just as all the other EF zoom lenses. The L version will again be a construction with high grade fluoride glass.

The construction of the 35-135mm zoom also includes aspherical elements. This lens will soon be available and is, despite its specification of 35-135mm f/3.5-4.5 i.e. covering four fixed focal lengths, relatively compact. Again, it has the close-up focusing setting over the whole focal length range. This lens should soon become one of the favourites of the travelling photographer who needs to keep his equipment to a minimum.

The design brief for the EF 28-105mm f/3.5-4.5 specified a large wide-angle range. Previous lenses with this specification needed a relatively large lens diameter for the front elements and thus a long closest focusing distance. This disadvantage is overcome in the new structural design by the use of aspherical lenses and a focusing system at the rear of the lens. The result is a compact construction with excellent reproduction quality.

Canon intend to extend their autofocus system further; this includes lenses and cameras. The EOS system will be totally compatible. Those of you who are buying a lens for their EOS 650 camera, should be able to use it even in 10 years time with

the newest EOS model. After all, the last bayonet served us faithfully for 29 years. The EF bayonet sets the scene for the Canon camera system well into the next century.

When considering the future of a camera system we have to think beyond the range of lenses and the lens/camera interface. Is the EOS really the first fruits of an entirely new concept in photography? What are the implications if we say "good-bye" to conventional photo-chemistry and move to electromagnetic image recording? The so-called "still-video" is already with us, promising a very wide range of application. Wasn't it Canon who caused a minor sensation at the 1984 Photokina with their still-video system? Considered in this way, may not the EOS 650 be one of the first steps on the way to an entirely new means of picture creation? The future prospects of a system, such as that embodied in the EOS, must be considered as quite distinct from those of the camera itself. The photo-chemical process is still the best means for producing high quality images, compared with other methods of image recording. The purchase of a modern high-tech camera still makes good sense because the film materials available are of such excellent quality. But the balance of advantage may tip in favour of electronic methods of image recording as the quality of that is rapidly improving. But much of the technology incorporated for the first time in the Canon EOS system will be just as valid then and equally applicable to electronic image recording.

Hints on Choosing the Most Suitable Equipment

Before you go to your photographic dealer you should consider very carefully what you wish to photograph, when and where. If you are particularly interested in indoor photography with flash, then you need not spend your money on one of the superfast lenses. The available light photographer, on the other hand, will have to think carefully about those moody scenes in the dusk. The weight of a lens is another consideration. A lens with a wide focal length range weighs more than a fixed focal length lens. Then there is to be considered whether you take your pictures from a close viewpoint, or prefer to catch that candid shot from a greater distance. All these considerations will play their part in deciding which of the lenses offered by Canon will combine to make your ideal outfit.

For Snapshot Photography

If you like to catch that special moment, then you have to be ready at all times. You have to think ahead, anticipating the event, and there is usually no time to change the lens at the decisive moment to capture the scene with the most effective frame. A wide-angle zoom is ideal for this purpose. The dedicated snapshot photographer always carries his camera with him, and the weight of the lens is therefore also an important consideration. The feather-light 35-70mm zoom is, no doubt, the first choice for the above considerations. It covers the range from the slightly wide-angle for landscape and group scenes down to the shorter telephoto range for format-filling portraits. If you are prepared to carry a heavier lens — and also pay a little more — then you could increase your chances by choosing the 28-70mm zoom. The extra focal length in the wide-angle range will allow you to cope in small rooms and you will be able to cover large buildings from a short distance. Much

Basic equipment for the snapshot photographer

Variant 1 for normal requirements:	Variant 2 for professional requirements:
EOS 650 together with EF 35-70mm f/3.5-4.5 zoom	EOS 650 with EF 28-80mm f/2.8-4.0 L
or EF 28-70mm f/3.5-4.5 zoom	and Canon Speedlite 420 EZ
and Canon Speedlite 300 EZ	and perhaps handgrip GR10
	Suggestions for further extension of equipment, variant 2:
	EF 50mm f/1.0 L
	and
	EF 70-210mm f/4 zoom

heavier and also much more expensive is the 28-80mm L zoom
with the very quiet and extremely fast ultrasonic focusing
motor. This lens will be the choice of professional photo-
graphers who make the highest demands on their equipment
and are prepared to accept the expenditure and the extra
weight.

Apart from a fast lens, the snapshot photographer will need
to carry a flashgun. Usually there is little time to carefully
prepare a shot and the Canon Speedlite 300 EZ should be
sufficient for most purposes. This is a small, handy flashgun
that covers the closer range quite adequately. Its illumination
angle is sufficient to cover even the angle of view of a 28mm
wide-angle lens. One disadvantage: it allows only direct

flashing. The automatically adjustable zoom reflector adjusts the flash according to the focal length selected on the lens for best possible utilization of the flash output. Snapshots are usually taken and generally best rendered from the close range and a telephoto lens is probably not necessary.

To complement the equipment you can always extend it later by adding a telephoto zoom lens. The classic 70-210mm telephoto zoom seems to be the most practical addition because of its relative light weight and great speed. One hint for those of you who have larger than average hands: the handgrip of the EOS 650 is exchangeable. Try handgrip GR10; it may feel more comfortable in your grip. The strap affords additional support.

For Portrait Photography

The medium telephoto lenses with focal lengths between 70 and 135mm are particularly well-suited for portrait photography. Canon developed the 135mm soft focus lens for this purpose. Those of you who decide on this lens, which can also be used as a normal telephoto lens without the soft focus facility, will be particularly interested in portrait photography. The soft effect draws a gentle veil over any imperfections and other ravages of time we often do not wish to show too clearly in a more flattering view of face and body. This lens has a large maximum apperture which allows the main subject to be seperated from the background by the resulting shallow depth of field. The romantic rendering of this lens is particularly suited for wedding and love scenes and other moody, romantic shots. It is possible to achieve this effect by simply breathing on the front lens, only it is not very controllable. The zoom lenses with focal length range 28-80mm and 35-105mm are also very

EOS Programming: shutter speed priority and partial metering.

Reason: snapshot exposure times are an absolute requirement for action shots. Partial metering was necessary as the unimportant, but quite expansive, background would have given a false reading. If in doubt, switch off AF priority in situations like these.

Photo: Werner Stein

useful for portraits and they are more versatile. The two other wide-angle zooms seem to be less appropriate as the most suitable focal length for this purpose start with 70mm. The 70-210mm would also be suitable for portrait photography. However, you should consider that hand-held shots with longer focal lengths are more critical because of the danger of camera shake.

In poor lighting, when flash is needed, it is better to use indirect flash. Direct flash gives a rather harsh, flat and unflattering illumination unsuitable for portraits. Backlit portraits are rather attractive as the strong light lends a nice halo effect to the hair. In this case the Speedite 300 EZ would be suitable as a fill-in flash, but the 'Speedlite 420 EZ is more versatile with its turn and tilt zoom reflector.

Basic equipment for the portrait photographer

Variant 1 for normal requirements:	Variant 2 for professional requirements:
EOS 650	EOS 650
and EF 35-105mm f/3.5-4.5	and EF 28-80mm f/2.8-4.0 L
and Canon Speedlite 420 EZ	and EF 135mm f/2.8 Soft Focus
	and Canon Speedlite 420 EZ
	and perhaps also EF 70-210mm f/4.0

EOS Programming: Aperture Priority with exposure correction.

Reason: a large depth of field is generally not wanted in portrait photography. Usually we would choose a large aperture on a longer focal length (here 85mm) with precise exposure. In this case an exposure correction of +1 f/stops was applied to enhance the subject's rugged look. Photo: Werner Stein

For Available Light Photography

Many photographers still reject flash on principle. The argument is that the flash destroys the natural atmosphere; that people posing for the photographer become more self-conscious in the presence of flash and that it makes candid shooting impossible. Canon have the answer for the enthusiastic twilight photographer: the standard lens with a speed of f/1.0. This truly remarkable lens is capable of catching even the dimmest glow of a candle and the super-quiet USM focusing drive makes your photographic activities as quiet as a mouse. The second standard lens in the system range with a maximum aperture of f/1.8 is also quite respectable as far as lens speed is concerned. The 28mm f/2.8 wide-angle would be another can-

Basic equipment for the available light photographer

Variant 1 for normal requirements:	Variant 2 for professional requirements:
EOS 650	EOS 650
and EF 50mm f/1.8	and EF 50mm f/1.0 L
and EF 28mm f/2.8	and EF 28-80mm f/2.8-4.0 L
and EF 135mm f/2.8 Soft focus	and EF 135mm f/2.8 Soft focus

EOS Programming: program mode with AF lock.

Reason: the centre-weighted integral metering ensures correct exposure because it also considers the bright subject areas. The autofocus mechanism would have focused on the background at the centre of the picture. It was therefore necessary to focus first on the tree and then to keep this setting to realign the frame.

Photo: Klaus Lipa

didate for low level lighting situations. If a longer focal length is required, then the 28-80mm L as a high-performance zoom produces excellent results even with a wide open aperture. The EF soft focus is another useful, high-quality lens that could serve you well. This 135mm telephoto lens has a speed of f/2.8 and could enhance the atmospheric impression with its soft focus effect. In any case, this lens can be used both for hard and soft focus.

For Architectural Photography

Buildings are usually quite large and often surrounded by others so that the photographer cannot choose his shooting position, but has to try to show the entire church, memorial, etc, from base to top, all in one frame. Wide-angle lenses were developed for this purpose. They allow large objects to be brought at a short distance into the 35mm frame. Currently the Canon system range includes two wide-angle fixed-focus lenses, the fisheye and the 28mm. The fisheye is hardly suitable for architecture, despite its very large angle of view. It represents horizontal and vertical lines increasingly curved towards the edge of the picture. We are therefore left with the EF 28mm f/2.8 wide-angle. If lens speed is of no major consideration, then one of the wide-angle zooms with the smaller minimum focal length would also be quite suitable. Another good combination may be the 28mm fixed focal length, together with either the 35-70mm zoom or the 35-105mm zoom. Architectural photography hardly ever calls for longer focus lenses. For interior photography you will also need a flashgun. In this case I would consider the more powerful Speedlite 420 EZ. In architectural photography you

EOS Programming: DEPTH mode with AF priority.

Reason: a typical subject requiring utmost sharpness from the close foreground to the far background. This is no problem for the EOS, particularly if the lighting conditions are good and a 28mm lens is fitted to capture the scene.
Photo: Klaus Lipa

will generally prefer the smaller apertures for greater depth of field and will thus, by necessity, often come across the need for slower shutter speeds, and a remote release would be a useful accessory for this purpose. To connect a remote control to the EOS you will need handgrip GR 20. You may find the exchange grid focusing screen a good aid to assist in the alignment of vertical and horizontal lines.

Basic equipment for the architectural photographer

Variant 1 for normal requirements:	Variant 2 for professional requirements:
EOS 650 with grid focusing screen Type D	EOS 650
	and
and	EF 28-80mm f/2.8-4.0 L
EF 28mm f/2.8	
	and
and	Canon Speedlite 420 EZ
EF 35-105mm f/3.5-4.5	
	and
and '	Remote release
Canon Speedlite 420 EZ	with handgrip GR20
or EOS 650 with grid focusing screen Type D	
and EF 28-80mm f/3.5-4.5	
and Canon Speedlite 420 EZ	

EOS Programming: shutter speed priority with partial metering.

Reason: as fast a shutter speed as possible was the most important requirement for this shot. Moreover, the great contrasts required partial metering for correct exposure. Photo: Karl Forster

For Sports Photography

In sports photography the main consideration is the compromise between the fastest possible shutter speed and a reasonably small aperture to obtain sufficiently large depth of field. A fast shutter speed will usually be of overriding importance to freeze the movement. The sports photographer will usually try to be as close to the action as possible to give his pictures maximum impact. The ideal lens, just as suitable for shots in a crowded football stadium as in an indoor hall covering an ice hockey match, is the EF 300mm f/2.8 L. However, this photographic gem will probably only be seriously considered by the professional sports photographer; the ordinary amateur photographer will almost certainly find it beyond his means. For less ambitious use, a faster film and one of the two

Basic equipment for the sports photographer

Variant 1 for normal requirements:	Variant 2 for professional requirements:
EOS 650	EOS 650
and EF 35-70mm f/3.5-4.5	and EF 70-210mm f/4.0
and EF 100-300mm f/5.6	or EF 100-300mm f/5.6 L
or EF 70-210mm f/4.0	and EF 300mm f/2.8 L

EOS Programming: aperture priority and manual focusing

Reason: clear, geometrical lines need to be rendered pin-sharp. In situations like these, with a confusing array of lines, the autofocus is better switched off. The EOS 650 also functions perfectly in manual focusing. Sceptics may prefer to judge the depth of field by manual settings.

Photos: Karl Forster

EOS Programming: shutter speed and release priority.

Reason: shutter speed priority comes into its own in sports photography. As in all other cases where fast shutter speeds are essential, a suitable speed is preselected and the camera's electronics will calculate the correct aperture value. The autofocus is sometimes not fast enough in sports photography, especially in continuous sequences where you always want to release at exactly the right moment. Photo: Klaus Lipa

100-300mm zooms will offer the best solution. In any case, these two lenses are lighter and more compact and therefore easier to handle than the "professional" 300mm heavy-weight. However, neither of these two zooms can compete with the biting sharpness with which this exceedingly fast 300mm lens depicts the main subject against the background. The very popular 70-210mm tele zoom, being one whole stop faster with a largest aperture of f/4.0 is another very good choice. The sports photographer will only rarely use flash because most activities he pursues are too far away for the reach of a flashgun and a flash triggered close to an athlete would interfere with his concentration and its use is usually not permitted anyway.

For Animal Photography

Animals are shy. The relatively long flight distance requires the use of long focal lengths in order to represent the animal in full frame. Then there is the problem that many animals prefer to show themselves — to the photographer's chagrin — in the early morning or at dusk. Even in the zoo or safari park there are often broad ditches separating visitors from their photographic prey. The animal photographer will therefore also need long focus lenses with high speeds. The 70-210mm may be

Basic equipment for animal photography

Variant 1 for normal requirements:	Variant 2 for professional requirements:
EOS 650 with handgrip GR20 for remote release	EOS 650
	and
	EF 100-300mm f/5.6 L
and	
EF 70-210mm f/4.0	
	and
or	EF 300mm f/2.8 L +
EF 100-300mm f/5.6	EF extender 2X

long enough for shots in the zoo, but in the wild you will need a lot of luck to be able to get close enough to take a useful picture with this lens. But animal photography does not only mean the safari in Kenya, or the golden eagle in wildest Scotland. The world is full of small, interesting creatures that are worth exploring. In this respect too, the Canon EF telephoto lenses prove their worth. All of them possess close-up settings across the entire focal length range. You are therefore able to use the telephoto setting to fill the frame with distant small creatures.

For Travel Photography

Mobility and lightness of weight is the main consideration here. Every ounce makes itself felt when you are travelling. The travel photographer prefers the compact lens with variable focal length. This equips him with the flexible outfit necessary to cope with the great variety of subjects that he may encounter. There are the candid portraits, impressive landscapes, interiors and exteriors of splendid buildings or ruins. If you are going abroad, you are best advised to take a wide-angle and a telephoto zoom lens with you. A flashgun would also be useful. For landscape photography a polarising filter should help to improve colour saturation. If you don't like flash or don't want to carry a flashgun, then you will have to ensure that your lenses are sufficiently fast. Canon offers a good selection in the medium ranges. You can make your decision between the greater focal length range, greater lens speed, or lighter weight. My suggestion for the ordinary requirements was based on a reasonable compromise, whilst the equipment for

EOS Programming: shutter speed and focus priority.

Reason: Here too a fast shutter speed is essential to avoid danger of camera shake because of the long focal length used to get close to the subject. As a general rule the shutter speed should be no slower than the inverse of the focal length (i.e. 250mm = $^1/_{250}$ second, 500mm = $^1/_{500}$ second, etc). Photo: Rudi Bacher

the professional photographer ensures the best possible reproduction quality.

Basic equipment for the travel photographer

Variant 1 for normal requirements:	Variant 2 for professional requirements
EOS 650	EOS 650
and EF 28-70mm f/3.5-4.5	and EF28-80mm f/2.8-4.0 L
	and EF 50mm f/1.0 L
and EF 70-210mm f/4	and EF 100-300mm f/5.6 L
and Canon Speedlite 420 EZ	and Canon circular polarising filters of 58mm and 72mm diameters
	and Canon Speedlite 420 EZ

Creative Flash Photography

The move into flash photography is an absolute delight for the EOS owner. Photographing with flash has never been as easy and so versatile. No other SLR system has offered as many creative possibilities as the EOS 650. The two flashguns specially developed for the EOS, the Canon Speedlite 420 EZ and the 300 EZ, are more than mere replacement suns lighting up a dark interior or other scenes. They are genuine multi-function instruments for individual light control and image creation, and the built-in infra-red auxiliary metering flash assists the power-eye autofocus system in total darkness.

Fill-in flash in daylight or backlit situations, previously a rather difficult technique, is now mere child's play. Special effects with fast or slow X-sync shutter speeds, super-fast flash sequences appropriate to the camera's motor drive speed, and the ability to trigger the flash immediately the shutter is fully open or directly before the second curtain starts to close it, are further examples of the seemingly inexhaustible repertoire of facilities of the EOS flash system. The reflector of the more powerful Speedlite 420 EZ may be turned for indirect flash and its super-fast flashing rate of 5 flashes per second makes even stroboscope shots possible. The A-TTL flash metering, already introduced with the T90, automatically adjusts for prevailing lighting conditions, measuring the correct amount of flash illumination for the available ambient lighting, regardless of whether you are shooting in total darkness or in brightest sunshine. Flash photography is also strictly in line with the overriding EOS principle: foolproof operation and total creative freedom. In principle, all flash photographs taken with the EOS and EOS system flashguns will succeed at the first try, but if you wish to get the best out of all the wonderful facilities that modern technology can offer, then you need to look a little closer into the underlying principles. This does not mean you need to understand the technical intricacies that were packed into these instruments, rather the creative possibilities that these open up.

A Bright Little Head:
The Canon Speedlite 300 EZ

Weighing only 315g with batteries, the small Canon Speedlite 300 EZ has quite a powerful output: the quite respectable metre guide number of 28. This allows illumination of a subject at a distance of 17m, using an ISO 100/21° film and the 50mm f/1.8 lens at fully open aperture.

What is a guide number? It is the measure of the power of a flashgun, normally defined for a film speed of ISO 100/21°. It is calculated as the product of f/number and distance. Considering it the other way round, you can calculate the distance of the flash from the subject by dividing the guide number by the f/number.

Example: The range of a flash with guide number 28 and working aperture f/4 is calculated as follows: 28 (guide number) ÷ 4 (f/number) = 7 metres (distance). If you are using an aperture of f/8 then the distance is reduced to 3.5m (28 ÷ 8 = 3.5).

Push the flash into the accessory shoe on the camera and secure with the knurled knob. The flashgun starts charging-up as soon as the main switch is turned on. How long it will take to fully charge will depend on how much energy was expended on the previous flash and on the condition of the batteries. If the flashgun is loaded with alkaline batteries the flash should be charged and ready after 0.3 to, at most, 8 seconds. Rechargeable batteries will charge the flash up in, at most, 6 seconds. A set of fresh batteries should produce somewhere between 200 and 2000 flash exposures, depending on the ambient brightness, distance to the subject, aperture value set on the camera and on the film speed. The capacity of rechargeable batteries lies somewhere between 65 to 650 flashes.

The automatically-operated zoom reflector ensures optimum use of energy and illumination output. This facility adjusts the illumination angle of the flash automatically to the angle of view of the lens attached, and if a zoom lens is

Canon Speedlight 300 EZ

attached, the focal length used on the lens. This is done internally in the flashgun. The chosen focal length may be read off the back of the flashgun. The reflector has four positions, for 28mm, 35mm, 50mm and 70mm focal lengths. The guide number of the Canon Speedlite 300 EZ will change depending on the reflector position. The guide number is reduced to 22 for the largest illumination angle for the 28mm wide-angle; using the telephoto setting of 70mm, the guide number increases to 30.

To save energy the Speedlite 300 EZ also has an automatic economy circuit, referred to as SE-function (save energy). This facility automatically interrupts the charging process if the flash has not been triggered within 5 minutes after switching on. To start the charging process the flash-ready lamp, which also serves as a test flash release, has to be depressed.

The flashgun receives from the camera not only information about the focal length of the lens attached at a given time, but also what film speed is loaded. The A-TTL control, which assesses the subject ambient illumination, measures the exact amount of flash illumination in the shooting modes: program, aperture priority and shutter speed priority. In manual

operation the flash duration is measured only by the light reflected from the film surface. The fastest flash synchronisation time is automatically controlled also in manual operation in case the shutter speed selected on the camera was too fast. If the range of the flash is insufficient for the subject, then aperture value and shutter speed will blink in the viewfinder to warn you. As mentioned previously, both Canon Speedlites have the facility to trigger the flash not only after the shutter has just been fully opened, but it is also possible to trigger it just before it is closed again. I shall describe the effects possible with this facility in another chapter. The flash has also a metering flash to assist automatic focusing in absolute darkness

A Powerful Companion: The Canon Speedlite 420 EZ

The Speedlite 420 EZ is a veritable tower of strength. This flashgun was specifically designed for the EOS. With guide number 35 it is not only more powerful than the 300 EZ, it also possesses a tilt and turn zoom reflector. It can be engaged in three intermediate positions upwards to 90° and to the left up to 180° in 6 positions. Turning to the right is possible in three stages to go up to 90°. Another difference from the smaller and lighter 300 EZ is that it is capable of a larger illumination angle; it can illuminate the angle of view of an 24mm wide-angle lens and in the telephoto range is can be adjusted to an 80mm lens when its guide number is increased to 42. Setting the position of the zoom reflector can also be done manually. When doing this you have to ensure that the zoom reflector position corresponds to, or is shorter than, the chosen focal length, otherwise the illumination would be uneven. On the other hand this effect could be used for a deliberate "spotlighting effect" of the centre section of the subject. The manual adjustment of the zoom reflector is done by depressing the zoom button on the flash which will set the motor in action. The zoom position

Canon Speedlight 420 EZ

may be read off the LCD panel on the rear of the flashgun. This is possible in absolute darkness as the LCD panel is illuminated by electronic luminescence via the light-key. The illumination will extinguish automatically 8 seconds after depressing this key. Apart from the reflector position, all other flash functions are displayed on the rear LCD panel.

The flash range, or the distance for which the flash will automatically supply the correct amount of illumination, may also be read off the LCD panel. If the reflector is turned or tilted for indirect flash then it will automatically go to the 50mm position and indicate this by displaying a symbol in the data panel. In manual flash control, and for stroboscopic function, the data is also displayed. It is not necessary to wait until the Speedlite has completely recharged to shoot a fast flashing sequence. It is possible to release even if the test lamp illuminates yellowish-green and only the guide number will be reduced for fast flashing sequences.

For normal flash photography the recharging time for the

420 EZ is about 0.2 to 13 seconds if alkaline batteries are used. For rechargeable batteries the recharging time is only 0.2 to 6.5 seconds. Switching to the fast flashing rate, the rate for both energy sources lies between 0.2 to 1.5 seconds. Fresh alkaline batteries should produce somewhere between 100 and 2000 flashes; for rechargeable batteries the rate lies somewhere between 45 to 300.

The shutter speed and aperture value displays in the viewfinder will blink to warn of incorrect exposure, i.e. if the subject is too far away for the flash output. If the distance is too short, then the distance range display will blink.

Flash Metering Modes with the EOS

A-TTL metering. The EOS provides two different modes of flash metering, ensuring correct flash control in all manual and automatic exposure modes. The EOS works not only with the well-proven TTL metering where the flash illumination time and aperture are controlled by measuring the light reflected from the film surface but Canon have developed this method further: the A-TTL method which stands for "Advanced" through the lens metering, i.e. an improvement of the method. This method has already proven its worth with the more expensive Canon T90.

The A-TTL flash control is the best possible link between camera electronics and flashgun. It ensures perfect pictures for any ambient lighting, from brightest sunshine to darkest

EOS Programming: aperture priority and partial metering.

Reason: shooting in aperture priority mode (shutter speed priority would have also been quite suitable) together with partial metering to allow for the brighter section at the centre of the frame. The EOS 650 is a particularly good traveling companion. The operational convenience and a perfectly graded range of zoom lenses allows you to carry with you a compact and very portable set of equipment that will master any situation that you are likely to encounter.

Photo: Klaus Lipa

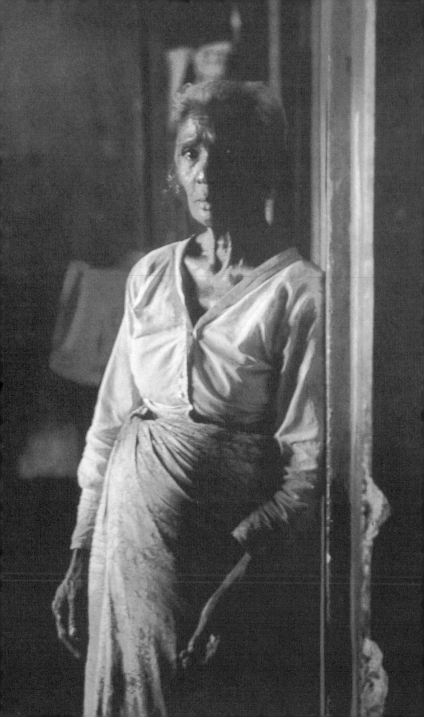

night. Other systems often suffer from deviations due to different reflection characteristics for different makes of film, this is impossible with the A-TTL method. Correct metering is achieved by issuing an infra-red metering flash immediately before the actual flash is triggered, i.e. just after the release button is half depressed. The light is reflected from the shutter blind and measured by the silicon cell in the mirror chamber of the camera. The camera therefore knows the brightness of the subject and background and controls, always according to the shooting mode chosen, the shutter speed and aperture. Using the A-TTL method and the program mode, even the most inexperienced photographer will produce technically perfect pictures right from the start. A-TTL metering with infra-red auxiliary flash is possible in fully automatic program mode and also with aperture priority and shutter speed priority mode, both for direct and indirect flash.

TTL-metering. If aperture and shutter speed are selected manually, then the flash will be controlled by the conventional TTL metering method (TTL = Through The Lens). The A-TTL method takes account of the illumination of both the background and the main subject. The TTL method, on the other hand, considers only the main subject and measures the correct flash illumination to expose only this correctly, as it uses only the light reflected from the film surface during the exposure, and uses this value to measure the appropriate amount of flash. If the camera is set to manual operation then the monitor on the camera will immediately display TTL instead of A-TTL. You can then select a suitable shutter speed. If the preselected shutter speed is shorter than the X-sync speed, then the camera will automatically change to the fastest

EOS Programming: see previous subject. This picture was taken with a 100-300mm zoom lens from the same shooting position as the previous picture. A very impressive proof of how useful and "travel-worthy" the compact zoom lenses for the EOS system are. *Photo: Klaus Lipa*

synchronisation time. It is thus impossible to get a partially-illuminated frame.

Flash Synchronisation Time. Cameras with focal plane shutters usually trigger the flash as soon as the first shutter blind exposes the entire frame. For very short shutter speeds the second blind follows the first before the first has actually reached the other side. As soon as the first blind exposed the frame, the second would have already covered some of it. A flash triggered at this moment would expose the frame only incompletely. The shortest flash synchronisation time is therefore that at which the entire frame is exposed to the lens. In the case of the EOS this is $1/125$ second. The special feature included in the EOS is also the possibility to trigger the flash shortly before the second curtain starts to cover the frame. This facility may be used to create interesting effects, particularly with slower shutter speeds.

Types of Flash Control

Flash in Program Mode. If the camera is set to "P", then the aperture and the shutter speed are automatically set by the camera. The photographer need only concentrate on catching his image when and how he intends. According to the subject brightness, the EOS 650 will select a shutter speed between $1/60$ and $1/125$ second. After the flash is charged, the flash ready symbol (a zigzag line), will light up in the viewfinder. Depressing the release lightly will focus the lens. The aperture value and shutter speed will blink in the viewfinder if the focusing distance is too great for the flash output. In this case you will have to move closer to the subject, until the new values in the viewfinder stop blinking. If the ambient light is quite bright and you are using the flash for filling-in, then it could happen that the aperture value begins to blink. The camera indicates with this that A-TTL control is not possible and only normal TTL flash metering for the main subject can be used. This will result

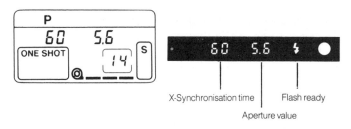

X-Synchronisation time | Flash ready

Aperture value

Displays in LCD panel and viewfinder for flash photography in program mode.

in overexposure of the background; the main subject, however, should be correctly exposed. The Canon Speedlite 420 EZ displays the aperture value used in the data monitor as well.

Flash with Shutter Speed Priority. In this shooting mode any suitable shutter speed may be preselected and the camera will select the appropriate aperture. Should you happen to choose a time shorter than the flash synchronisation time, then the EOS will automatically change to $^1/_{125}$ second. The aperture value and synchronisation time will be displayed in the viewfinder. If the Canon Speedlite 420 EZ is used, then the aperture value will also be displayed in the data panel. The flash output is sufficient if the aperture value and shutter speed are constantly lit. If both values blink, then the shooting distance is too great and the photographer has to move closer to the subject until a new metering result no longer flashes. Blinking of the largest possible aperture value in the viewfinder indicates that the A-TTL metering cannot illuminate the background sufficiently. The main subject, however, will be properly illuminated. Selecting a slower shutter speed could stop the blinking of the aperture value. In that case the A-TTL metering would find that the illumination is sufficient both for the main subject and the background. This may lead to camera shake because of the relatively slow shutter speed required. You also need to remember that the bleep warning for camera shake is inoperative in flash operation. If the display for the

127

smallest possible aperture blinks in the viewfinder then this indicates that the A-TTL control cannot satisfactorily adjust the illumination levels, i.e. the background would be overexposed, the main subject, however, would be correctly illuminated. Again, the choice of a faster shutter speed could correct this situation, provided this does not take you into speeds faster than $^1/_{125}$ second, as flash shots are not possible beyond this time.

Flash in Aperture Priority Mode. Setting the camera to "Av" you select the required aperture value and the camera will automatically select a shutter speed between 30 seconds and $^1/_{125}$ second. Taking a flash photograph in aperture priority mode is usually required if you wish to achieve as great a depth of field as possible, which means stopping down as much as possible. This shooting mode is also very suitable for fill-in flash with very contrasty subjects or backlit portraits and also for photographs with long flash synchronisation times. You need to remember though, that the camera will select relatively long synchronisation times if the available light is rather dim and this could lead to camera shake. Again, there is no warning for camera shake.

As previously, in shooting with flash in aperture priority, the displays for aperture value and shutter speed will blink in the viewfinder if the distance to the subject is too great for correct flash illumination. If the display of the slower possible shutter speed with flash blinks, then this means that A-TTL control is not possible, i.e. the background will be underexposed, but the main subject will be correctly illuminated. In this case the flash will be controlled by normal TTL control. To obtain balanced illumination of background and main subject, a larger aperture has to be selected so that the shutter speed of 30s stops blinking. The camera indicates that the A-TTL metering cannot adjust the flash illumination and the ambient light and that the background will be overexposed if the display for the fastest flash synchronization time blinks. In this case you have to stop down the aperture to attain A-TTL control conditions.

Flash with Manual Preselection of Aperture and Shutter Speed. Even if the aperture and shutter speed are selected manually, the camera will take care of the automatic measuring of the correct amount of flash illumination. A-TTL metering, however, is not possible in this shooting mode. In this mode the correct amount of flash illumination is determined by measuring the light reflected from the film surface by TTL metering. The camera is set to "M". On the data monitor of the Canon Speedlite 420 EZ the A-TTL display is replaced by the TTL display. As soon as the flash is recharged the camera automatically switches to $^1/_{125}$ second in the case that a longer shutter speed has been selected manually. If a slower shutter speed between $^1/_{125}$ to 30 seconds has been selected then this will not be changed. The illumination range for flash with manual settings changes with the reflector position. The smaller the angle of view, the greater the range. The film speed and the aperture are the other two factors affecting the range of the flashgun. The bigger the aperture, the greater the film speed and the smaller the angle of view, the greater the flash range. The data display on the Canon Speedlite 420 EZ informs you about the distance range for TTL control.

If this display blinks, then it is impossible to obtain correct exposure. The display of range extends to 30m. Distances greater than 30m are indicated by a triangular marker. If you are using the 300 EZ, then you have to refer to the table in the manual for possible shooting distances. TTL control with manual preselection and fast shooting sequences cannot be combined as the flashgun has to be fully recharged before every exposure.

There are situations which are not suitable for automatic flash control. For example, shots of dark subjects in front of a brilliant white background, or many small subjects in front of a distant background. The background could confuse the automatic flash control and cause incorrect exposures. For this reason the Speedlite 420 EZ has been equipped with a manual override which allows you to determine the required amount of

flash illumination. To use this facility depress the "manual" button on the flashgun after the flash-ready sign lights up and select the required flash output. The six possible output levels may be read off the data panel: M 1/1 is full output, M 1/2 is half the output, M 1/4 one quarter and so on down to M 1/32. Manual control of flash output has to be done with the camera in manual mode. If you failed to set it to manual the camera will indicate this by flashing the largest aperture value of the lens in the viewfinder and in the data monitor. The shutter speed may be preselected for any value between $^1/_{125}$ and 30 seconds. If the preselected time is shorter than $^1/_{125}$ second then the camera will automatically adjust to $^1/_{125}$ second. The correct flash distance can be read off the display panel on the Canon Speedlite 420 EZ. The range changes with the manual adjustment of the aperture and is as such adjustable to the subject distance. To do this you depress the key for manual aperture setting and turn the input dial at the same time until the suitable aperture is set.

In the data panel the changing flash range is displayed with changing aperture and you open up or stop down the aperture until the suitable distance is displayed. For subject distances in excess of 30m a triangular symbol will be displayed to the right of the distance display in the data panel. A blinking distance display indicates that correct flash exposure is impossible. Fast flashing rates are possible from M 1/4 because the flash requires longer charging times for the full or half the flash output. To change to automatic flash you only need to depress the A-TTL key on the back of the flashgun and the automatic functions are activated.

Stroboscopic Flash

A speciality of the Canon Speedlite 420 EZ is the possibility to trigger the flash several times during one exposure. This method of multiple exposure allows you to depict individual phases of a movement in one frame. To make use of this facility

the camera has to be set to manual mode, the flash synchronisation time has to be at least 1 second or longer. It is also possible to use long exposure setting "B" for this purpose. At the rear of the flashgun, buttons MANU and SYNC have to be depressed. The display on the data monitor of the flash will show M 1/1 for full output and MULTI 1 Hz for the flash frequency. The flash output may now be determined by depressing the MANU button; the SYNC button allows selection of flash frequency. Flash frequences of 1 to 5 flashes per second are possible. A display of 1 Hz means that one flash per second will be triggered. 5 HZ means 5 flashes per second. The number of possible flashes that may be fired in one go depend on the preselected output level. Please refer to the table for values.

The best conditions for impressive stroboscopic shots is a dark and fairly distant background. A set of fresh batteries and a tripod will be almost essential. The best conditions may be created in a completely dark room, draped with a matt black background. The background rolls of paper, that are available for studio photography from Hama, Durst and PSAL are very suitable, if a bit expensive, and they do not reflect a lot of light. The background should not reflect any light because the film should be illuminated only at the moment when the subject is illuminated by the flash, the rest should remain unexposed, i.e. black. A subject moving in front of the camera will thus be frozen in its movement every time the flash illuminates it. The rest remains without detail. The faster the flash frequency, the more stages of the movement will be shown.

A tripod is very important for this type of shot as a secure camera position will allow you to determine exactly the subject space within which the movements are to be captured. Moreover, if you moved the camera position during shooting the common central core of the phases of the movement would be obscured, thus destroying the dynamic impact. The faster the frequency, i.e. the shorter the period between flashes and the slower the movement, the more superimposed the individual phases of the movement. This may lead to over-

exposure in areas of multiple superimposed cores, because the subject is exposed several times on this particular section of the film. To avoid these effects it is better to choose rather fast moving subjects. It is important to arrange that the static parts remain in the same position for subjects of people, with only parts of their anatomy moving. A slight shift would blur the outline of this static core. Moreover, the static parts are exposed with full flash every time, the moving parts only once in their particular phase of the movement.

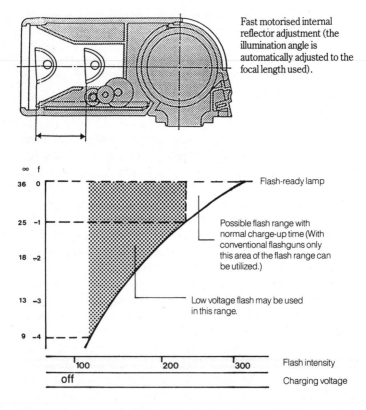

Fast motorised internal reflector adjustment (the illumination angle is automatically adjusted to the focal length used).

Flash-ready lamp

Possible flash range with normal charge-up time (With conventional flashguns only this area of the flash range can be utilized.)

Low voltage flash may be used in this range.

Flash intensity

Charging voltage

Fast flashing rates with low voltage flash.

132

Let's take the example of a sprinter jumping over a hurdle taken at five flash exposures per second, then the fixed hurdle would be hit five times by the flash and will therefore be rather overexposed compared with the five separate images of the hurdler. The photographer can adopt a few tricks to overcome these difficulties. If possible paint the hurdle in a dark colour and ensure that the hurdler wears light reflective clothing.

Indirect Flash

A flash fired directly at the subject tends to produce rather flat illumination with heavy cast shadows. This is particularly noticeable and unpleasant in cases of portraits or other subjects taken immediately in front of a wall or similar background. The heavy shadows appear as dense, dark, and unnatural areas as they are indeed caused by an unnatural light source. The A-TTL control is capable of reducing this effect to a great extent but it cannot be avoided altogether. In this case indirect flash is the answer. Pointing the reflector either upwards at the ceiling or towards a white wall, allowing it to bounce at an angle onto the subject, produces a soft, much more flattering effect. The tilt and turn zoom reflector of the Canon Speedlite 420 EZ may be turned in any direction and through 180° upwards. The automatic flash control remains fully operative. One factor needs to be remembered; the colour of the reflecting surface, i.e. the ceiling or the wallpaper, influences the colour and intensity of the reflected flash and this in turn the range of the flashgun. The symbol for indirect flash appears on the flashgun data display and the flash angle is automatically adjusted to that of a 50mm lens, when turning the zoom reflector from its normal position.

The reflector position may also be adjusted manually for a given flash angle. Sometimes it may be more appropriate to select a smaller flash angle on the zoom reflector, because the flash light is dispersed through a wider angle by the reflection. To turn the reflector, the lock at the rear has to be turned

upward. Contrary to the invisible infra-red type metering flash that is emitted for direct flash, the Canon Speedlite 420 EZ emits a visible metering flash after the release is depressed lightly to determine the correct flash intensity.

If there is no suitable white or light wall or ceiling available, then you can use a white card or polystyrene panel as a reflection surface. The surface against which the flash is to be bounced should not be too far away from the subject so as to utilise the flash output to its maximum.

Delayed Flash

Cameras with focal plane shutters usually release the flash as soon as the first shutter curtain has exposed the frame fully. The two Canon Speedlites 300 EZ and 420 EZ offer the possibility of releasing the flash just before the second blind moves to close the shutter. This is simply done by moving a small slide switch at the back of the flashgun. This is particularly effective for flash photographs with moving light sources, such as car headlights and rear lights, together with reasonably slow shutter speeds. An unlit object is often stopped in its movement when a flash is triggered. The available light, however dim, let's say the candles on a birthday cake or the lanterns in a procession, illuminate the subject to a certain extent. This movement is caught on film as a ghost-like trace, echoing the movement against the sharply outlined instant frozen by the triggered flash.

A moving subject, the headlights or the lantern bearer, is illuminated by the flash and the subsequent illumination with long exposure creates a trace that moves ahead. The delayed flash, however, traces the movement first and ends with the sharply illuminated flash image, the movement trace lies behind, just as the actual movement. This effect is more pronounced the darker the surroundings and the slower the selected shutter speed. In choosing a suitable time you will have to be careful not to exceed the time it takes the subject to

move across your angle of view so that the flash does not trigger until the subject is out of the camera's sight. The delayed flash is also possible in "B" setting. In this setting it may be easier to determine when to trigger the flash. The duration of open shutter in long exposure mode is displayed in the panel of the camera.

Fill-in Flash

The film cannot see everything that the human eye is capable of discerning. The range of contrast present in most subjects is a problem for every film. Slide films, in particular, are very critical. Colour print films are capable of coping with a greater contrast range.

What is contrast range? It is the ratio of the brightest to the darkest area of the subject. The contrast range is a factor in determining exposure of the subject and the reflectivity of its individual surfaces. The contrast range is automatically assessed by the EOS by the multi-field metering method. Manually this may be done by measuring the dark and the bright areas by the partial metering method. A contrast range of one aperture stop corresponds to a ratio of 1:2, for two stops to 1:4, for 3 stops to 1:8, and so on.

Excessive differences in brightness inevitably leads to overexposure of the bright areas and underexposure of the dark shadow parts. To avoid too heavy shadows in subject parts not lit by direct sunlight, professionals use fill-in reflector screens or flash. A screen may be difficult to install and flash was once difficult to use, requiring a lot of complicated calculations and measurements to produce the required results. This is no longer a problem with the EOS 650. The multi-field metering method adopted by the camera, assesses the different areas of the image and adjusts the intensity of the flash exactly to the prevailing conditions. It does not matter if the flash is to be used for backlit shots in bright sunlight, or if it is needed to increase the contrasts in dim lighting conditions —

to bathe the subject in a touch of "sun", or to enhance a dimly-lit, poor contrast subject — the EOS 650 with A-TTL control and multi-field metering will always provide the best possible balance between background and main subject.

It could happen, however, that the bright background of a subject is overexposed despite the smallest possible aperture and shortest synchronisation time. This could occur in particular if a fast film is used. In this case the camera will indicate this situation by the blinking display of the smallest lens aperture in the viewfinder. This means that the illumination of the main subject and the background cannot be satisfactorily adjusted. Despite this, the flash for the main subject will be correctly regulated under these circumstances. For fill-in flash the EOS is best set to program mode or shutter speed priority mode. In the first instance the camera will select a shutter speed between $1/60$ and $1/125$ second, according to the brightness of the subject. In shutter speed mode the fastest shutter speed could be preselected, to avoid camera shake — the camera-shake warning signal is inoperative in flash mode. Should you have set the camera to DEPTH then it will automatically revert to automatic program mode.

Flash with other Canon Speedlites

The Canon Speedlites 420 EZ and 300 EZ are specifically designed for the EOS system. Other Canon Speedlite models are suitable for automatic flash photography with some limitations however. Set the EOS to "M", then select the required flash synchronisation time between $1/125$ and 30 seconds. Should you have selected a faster shutter speed the camera will correct this by automatically selecting $1/125$ second. The aperture selected on the camera has to be manually set on the flash. If the Canon Speedlite 300 TL is used, then you only need to depress the A-TTL and the FEL buttons. Speedlites 277T and 299T have to be used in operating mode F.NO.SET, i.e. manual aperture selection. The 244T and other flash

accessories in the Canon range are not suitable for the EOS. The use of a studio flash with the EOS necessitates manual setting of aperture and shutter speed. Studio lights are connected via a hot-shoe adapter. The use of flashguns with more than two contacts from other manufacturers is not recommended as these might cause damage to the EOS.

On the other hand, experience has shown that flashgun manufacturers are quick to develop a suitable product for a new camera system after a surprisingly short time. It is understandable that a camera manufacturer does not want to make it easy for an accessory or lens manufacturer to compete with him. Flashgun manufacturers, such as Metz, Osram, Cullman and Regula, cannot be disregarded. They have demonstrated in the past that their expertise is considerable, and purchasers seem to be quite prepared to put up with the inconvenience of having to use an adapter if one of their flashguns offer other advantages. At the time of writing, some interesting developments can be observed on the part of independent manufacturers heralding the introduction of EOS-compatible flashguns.

Even the Back can be a Delight

Quartz Data Back E

The simple quick release hinge of the EOS enables the standard back to be readily replaced by one of the other special purpose databacks. The simplest of these is the Quartz Data Back E. This allows you to print various data onto the film. Various ways of doing this are available. Either the date is automatically exposed onto every frame, and this is possible in three different forms: either the day, followed by month and then year, or the year, then month and day, or even month,

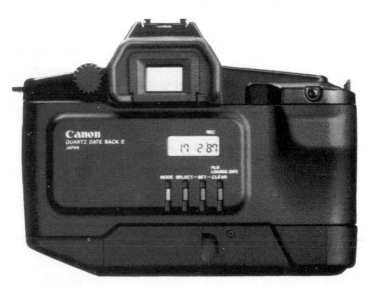

Quartz Data Back

then day and finally the year. If this is not sufficient, you can also print the time on the frames. The databack is programmed to the year 2029 and also has a quartz clock.

Instead of the date you could expose a six-digit number combination. Consecutive, four-digit frame numbers, starting from 0001 to 9999 are also possible. The databack also remembers the date when a film was loaded and this may be recalled by depressing a button. All data to be exposed can be displayed on a LCD monitor at the touch of a button. The data itself is entered via four keys. Naturally, it is possible to inactivate the data exposure. Another facility offered by the quartz databack is the timing by integrated clock of long exposures up to 23 hours 59 minutes and 59 seconds.

Technical Back E

This version of databack is a real technical marvel. You can expose not only numbers and letters, but also exposure data such as shutter speed, aperture value, focal length and film speed. Up to thirty different characters may be programmed. But this databack does not only expose various data onto the film, it is also capable of undertaking certain control functions on camera and flash for interval shots. In the "bulb" position the longest exposure time is 120 seconds; with this databack you can determine exposures of several hours, for example in astro photography. Using the Technical Data Back for interval shots with flash, the databack will set the Speedlite 420 EZ or 300 EZ to charge about 30 seconds before it is programmed to trigger the flash. For scientific use there is an additional accessory available; Keyboard Unit E, this allows you to print any wording onto the film by keying-in the appropriate characters on the keyboard. But this is not all — there is also Interface TB which allows the databack to be connected to an MSX or IBM compatible PC. Now you can enter commands in the computer which may be checked on the screen and then issued directly to the camera.

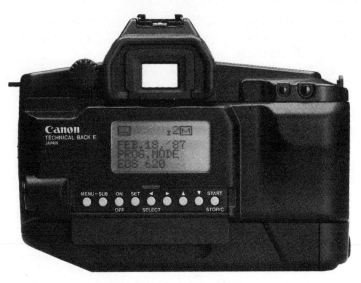

Technical Back E with external Keyboard Unit E (below)

EOS Programming: aperture and focus priority.

Reason: another example where a correctly employed large depth of field is of the utmost importance. You can check the depth of field by pressing the depth of field button. However, the image in the viewfinder will be rather dark.

Photo: Hermann Groeneveld

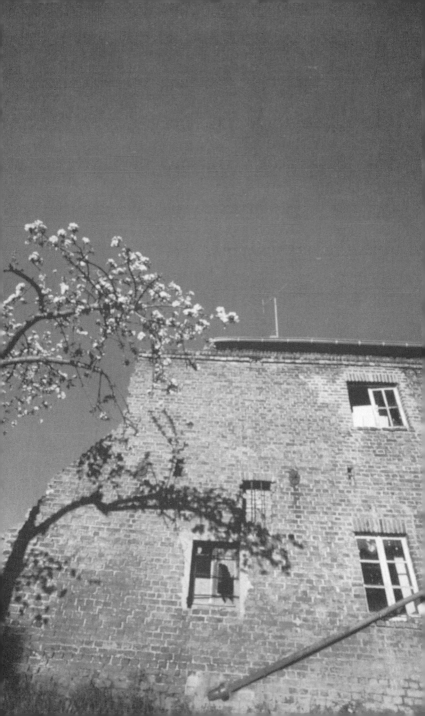

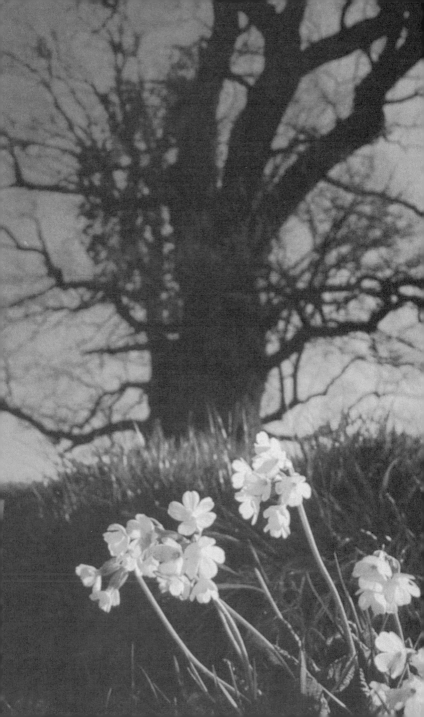

Checklists

I have provided the following checklists so that you may confirm what you know about your EOS and as a quick guide to all the essential information about the EOS system. If you want to check whether you know everything that I have listed, simply cover the explanations on the right-hand side of the page. First there is an explanation of all the operating elements on the EOS 650. On the left is the description of the operating element, next to it the symbol and description of its function.

The Main Operating Elements

Description	Function
Main switch	The main switch on the top left back of the camera has four positions:
	L — the camera is switched off.
	A the camera is– switched on for selection of programs via input dial.
	(◦) The same as position A, but with the difference that a short bleep sounds when correct focusing is attained, and a long one to warn you of danger of camera shake because of a slow indicated shutter speed.
	☐ full automatic exposure mode with autofocus in "One Shot".

EOS Programming: aperture priority and partial metering, AF lock.

Reason: the limited depth of field is used to good effect: the sharply-defined foreground is emphasised against the blurred background. Depth of field is an important tool in image creation. The autofocus proves its worth particularly in the close range. Photo: Hermann Groeneveld

Operating Elements of the EOS 650

1 Distance scale
2 Self-timer, operation indicator LED
3 Grip (GR 30)/battery compartment cover
4 Shutter button
5 Electronic input dial
6 LCD panel
7 Accessory shoe
8 Mode button
9 Film plane indicator
10 Exposure compensation button
11 Neckstrap lug
12 Lens release button
13 Focus mode switch (automatic/manual)
14 Film cassette window
15 Back panel
16 Film rewind button
17 Autofocus mode selector
18 Film winding mode selector
19 Battery check button
20 Partial metering button
21 Viewfinder eyepiece
22 Grip attachment screw
23 Manual focusing ring
24 Depth-of-field check button
25 Manual aperture setting button
26 Back cover latch
27 Back cover lock button

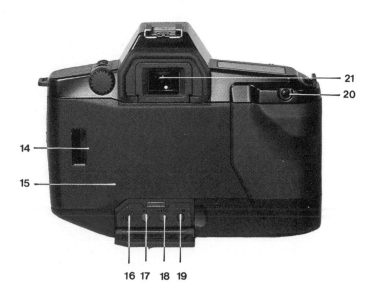

144

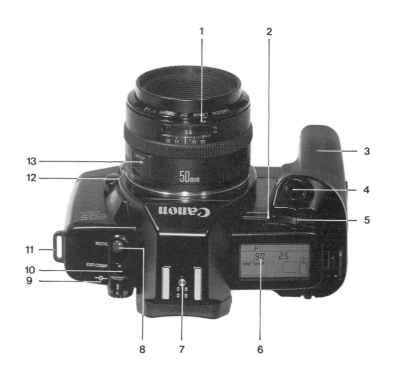

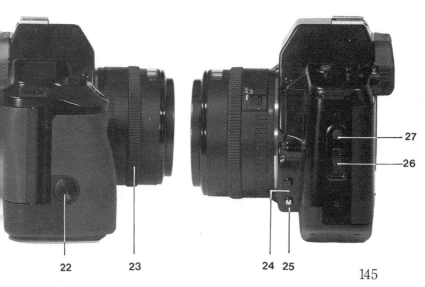

145

Description	Function
Shutter release	Electronic two-stage release. The AF and exposure metering systems are activated when the shutter release is depressed half-way. The indicated focus setting and metering values remain in the memory as long as the release is kept half-way depressed. The shutter is released only if correct focusing is obtained; if the camera is set to ONE SHOT function. In the SERVO function pressure on the release will trigger the shutter at any time.
Electronic input dial	In connection with other operating elements it is possible to select various data or functions. 1. Selection of the exposure programs: depress Mode-key, set main switch to A or (◦). 2. Entering of exposure compensation: depress exposure compensation button. 3. Manual aperture setting: depress manual aperture setting button. 4. Selection of AF-program: depress AF mode selector. 5. Selection of frame frequency: depress the film winding mode selector. 6. Manual film speed setting: simultaneously depress the yellow and blue buttons behind the switch cover.
Mode button	Depressing this button and turning the input dial selects one of the exposure programs.

Description	Function
Exposure compensation button	By depressing this button and turning the input dial you can select the appropriate exposure compensation.
Depth of field check button	Push the depth of field check button and the camera will stop down the aperture to either the automatically calculated or manually selected value, which is then visible in the viewfinder.
Manual aperture setting button	When this button is kept depressed the aperture value can be selected via the input dial.
Partial metering button	This button activates the partial metering function. The automatic metering lock is activated at the same time. The metered value remains in the memory as long as the release button is kept depressed half-way.
Lens release button	This button releases the lens lock to change the lens.
Accessory shoe	The accessory shoe has been provided to attach the specially-designed Canon Speedlites 420 EZ and 300 EZ for the EOS system. Studio flashguns may be connected via an adapter. Other Speedlites may be used but with certain restrictions.

The Four Buttons under the Switch Cover

Rewind button	The button on the far left activates rewinding of a partially exposed film.

Description	Function
AF program selection button	Depressing the yellow button and turning the input dial selects between autofocus program ONE SHOT, i.e. single shots, and SERVO for series.
Film winding mode selector	Depressing this button and turning the input dial selects between single shot, continuous shooting and self-timer.
Battery check button	This button is depressed to check the state of the battery which is indicated in the display panel.
Manual film speed setting	Simultaneously depressing the yellow and the blue buttons under the switch cover allows selection of the film speed by turning the input dial.

Operating Elements on the Lens

Slide switch to select focusing mode	This switch selects between manual and autofocus facility.
Manual focusing ring	This ring allows manual focusing by mechanical coupling with the focusing system. The manual focusing ring is in the fixed position when autofocus function is selected.

Creative Possibilities in Exposure Control

Intelligent Program Mode	The camera decides, by considering the focal length employed at the particular

Description	Function
	time, which shutter speeds are suitable to avoid camera shake or if smaller apertures should be preferred for greater depth of field. For shutter speeds slower than the reciprocal value of the lens focal length in mm (1/focal length) an acoustic signal sounds to warn of danger of camera shake. Overexposure warning: the fastest shutter speed of $1/2000$ second blinks in the viewfinder and in the monitor. Underexposure warning: the shutter speed display blinks for 30 seconds in the viewfinder and in the display panel.
Aperture Priority Mode	The photographer selects the aperture to control the depth of field. The camera calculates the correct shutter speed. This program is particularly suitable for landscapes, portraits or still-life where the depth of field is an important factor in image creation. If the resulting shutter speed is too slow for hand-held shots then the camera will indicate this by sounding a warning, if this has been selected. In this case it would be advisable to use a tripod. Overexposure warning: the fastest shutter speed of $1/2000$ second blinks in the viewfinder and in the display panel. Underexposure warning: the shutter speed display blinks for 30 seconds in the viewfinder and in the display panel.
Shutter Speed Priority Mode	In this shooting mode the photographer selects the shutter speed and the camera chooses the appropriate aperture value.

Description	Function

This program is particularly suited for fast moving subjects to freeze their movement. On the other hand, it also allows you to express the dynamics of a movement by choosing a suitable speed for blurring fast movements. No camera shake warning is given in this mode.

Overexposure warning: the smallest aperture value blinks in the viewfinder and in the display panel.

Underexposure warning: the largest aperture value blinks in the viewfinder and in the display panel.

DEPTH Mode

This exposure mode allows you to determine exactly the spatial depth within which the subject is depicted in sharp focus. To do this you first measure the point closest to you that has to be in sharp focus, then the point furthest away. The camera then selects the appropriate aperture and shutter speed. If the required setting is impossible to obtain, then the camera will indicate this by blinking the smallest available aperture value both in the viewfinder and in the display panel.

Overexposure warning: the smallest available aperture value and the shutter speed display blink in the viewfinder and in the display panel.

Underexposure warning: the largest aperture value and the shutter speed display for $^1/_{2000}$ seconds blink in the viewfinder and in the display panel.

Description	Function
Manual Exposure Setting	In this shooting mode it is possible to manually select both the aperture value and the shutter speed to suit the creative intent. The camera compares the chosen manual exposure setting by displaying some symbols in the viewfinder and the display panel. Correct exposure: OO displayed in the viewfinder and in the panel. Underexposure: display of OP in the viewfinder and panel (OP = open aperture or use slower shutter speed) Overexposure: display of CL in viewfinder and display panel (CL = close aperture, or use faster shutter speed)
Partial Metering	With this metering function only 6.5% of the viewing field is considered. This corresponds to the circular metering area at the centre of the viewfinder. The partial metering function helps to find correct exposure values for very contrasty subjects. The metering lock is always automatically activated when partial metering is selected. For sequence shots the metered value always stays in the memory, as long as the release is kept depressed. Selection of partial metering function is displayed in the viewfinder by the green * symbol.
Exposure Compensation	The exposure compensation facility is particularly useful for intentional over- and underexposures — the so-called high-key and low-key shots. It allows corrections in

Description	Function
	half stops to +/- 5 aperture stops. The +/- symbols in the viewfinder and the display panel indicate that a correction has been made.
Auto Flash Mode	Automatic flash exposure is possible in all shooting modes. If the the depth-of-field mode DEPTH is selected then the camera will automatically change to normal program mode. Should you have selected a faster shutter speed than the synchronisation speed of $1/125$ second, then the camera will automatically select this shutter speed. Flash-ready and correct flash exposure are indicated in the viewfinder by the flash symbol.
Long Exposure	Shutter speeds longer than 30 seconds are performed in the "bulb" setting. The shutter stays open as long as the shutter button is kept depressed and the time elapsed is displayed in the LCD panel. It is possible to time exposures of up to 120 seconds without any extra accessory. Using the Quartz Databack it is possible to control exposure times of up to 23 hours 59 minutes and 59 seconds. No incorrect exposure warning is given in this mode.

Autofocus and Film Winding Modes

ONE SHOT — Autofocus	The focus setting is held as long as the release is kept depressed half-way. Releasing the shutter is possible only if correct focusing has been achieved. This

Description	Function
	program is particularly useful for shots where the main subject is not to be placed at the centre of the frame.
SERVO — Autofocus	Automatic focusing constantly follows the moving subjects or the camera movement. The subject has to be at the centre of the viewfinder. This AF program is suitable for fast action shots.
Film Winding Mode	The EOS 650 has two frame frequencies. S: single frame mode. Every time the release is depressed the shutter is released once. The film is automatically wound to the next frame. C: the camera exposes at a rate of about 3 frames per second as long as the release remains depressed. Self-timer: the shutter operates about 10 seconds after the release has been depressed. The lead-in time is indicated by blinking of the self-timer light at the front of the camera.

Viewfinder Displays

M	Display for manual operation
M + OP	Display for manual operation, indicating that the aperture has to be opened for correct exposure.
M + OO	Display for correct, manual exposure
M + CL	Display for manual operation, indicating

153

Description	Function
	that the aperture has to be stopped down for correct exposure.
* (green)	Indicates that partial metering is activated.
Shutter speed display	The display is constantly lit if exposure is correct or in shutter speed priority. Underexposure warning in aperture priority mode: the display for the longest exposure time of 30 seconds flashes. Overexposure warning in aperture priority mode: the display for the shortest exposure time of $1/2000$ second flashes.

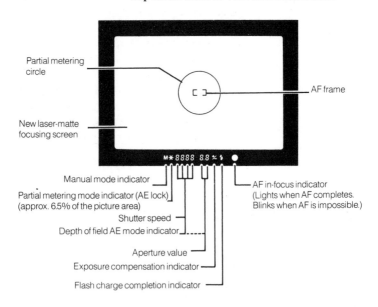

Partial metering circle

AF frame

New laser-matte focusing screen

M✳ 8888 8.8 ≈ ⚡ ●

Manual mode indicator

Partial metering mode indicator (AE lock) (approx. 6.5% of the picture area)

Shutter speed

Depth of field AE mode indicator

Aperture value

Exposure compensation indicator

Flash charge completion indicator

AF in-focus indicator (Lights when AF completes. Blinks when AF is impossible.)

Aperture display	The aperture value display stays lit if the exposure is correct or if aperture priority

Description	Function
	has been selected.
	Underexposure warning in shutter speed priority: the display of the widest available aperture flashes.
	Overexposure warning in shutter speed priority: the display for the smallest aperture on the lens flashes.
	Depth of field program: the smallest available aperture value flashes if the metered depth of field cannot be obtained.
	In flash mode: the smallest aperture value flashes for fill-in flash if A-TTL control is not possible, i.e. the background would be overexposed. The main subject will be correctly illuminated.
	The largest aperture value flashes to indicate that A-TTL control is not possible. The background will be underexposed, the main subject will be correctly illuminated.
Aperture value and shutter speed displays blink	Underexposure warning in program mode and depth-of-field program: the largest available aperture value and the longest shutter speed of 30 seconds blink.
	Overexposure warning in program mode and depth of field mode: the smallest available aperture value and shortest shutter speed blink.
	In flash mode: aperture and X-sync time blink to warn that the flash output is insufficient for the subject distance.
dEP 1	This display appears in the depth of field program, indicating that focusing for the first distance point has been performed.

Description	Function
dEP 2	This display appears in the depth of field program, indicating that focusing for the second distance point has been performed. If the release is now depressed again the aperture and shutter speed will be displayed. You can then release.
+/-	The +/- display illuminates if an exposure compensation has been effected.
Flash symbol	Illuminates continuously if the flashgun attached is ready charged.
AF-LED	The green in-focus display illuminates constantly to indicate that correct focus has been set. This display flashes if automatic focusing cannot be achieved.
Rectangular metering field	Field outlining area for automatic focusing.
Circular metering field	Metering field for partial exposure metering.

LCD Symbols

M	Manual exposure program
P	Intelligent program mode
Tv	Shutter speed priority mode
Av	Aperture priority mode
DEPTH	Depth-of-field mode

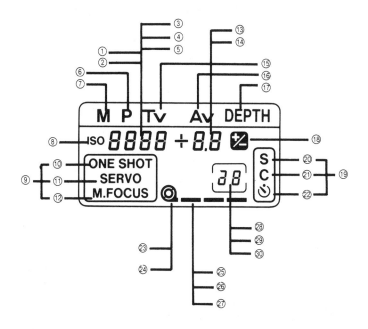

1 Exposure programs
2 DEPTH mode (dEP 1, dEP 2)
3 Film speed
4 Shutter speed
5 Manually metered exposure values
6 Program AE mode
7 Manual
8 ISO
9 AF autofocus program
10 AF-ONE-SHOT
11 AF-SERVO
12 Manual focusing
13 Exposure compensation
14 Aperture value
15 Shutter speed priority
16 Aperture priority
17 DEPTH mode
18 Exposure compensation (+/-)
19 Frame frequency mode
20 Single frame mode
21 Continuous frame mode
22 Self-timer
23 Film cassette symbol
24 Film cassette symbol blinks when film is rewound
25 "Film loaded" check, cassette rewind check
26 Film transport check
27 Battery check
28 Frame number display
29 Self-timer countdown
30 Long exposure time countdown

Description	Function
ISO	Film speed display
bc---	Sufficient battery voltage
bc--	Keep spare battery at the ready
bc- (bar flashes) or bc	Replace battery
S	Single frame mode
C	Continuous shooting
.)	Self-timer function is selected
ONE SHOT	AF-program mode: lens remains in focusing setting as long as release is kept depressed half-way.
SERVO	AF-program mode: automatic focusing follows the camera or subject movement.
M.FOCUS	Manual focusing
30'' 1.8	Both the shutter speed value for slowest shutter speed of 30 seconds and largest aperture value blink to indicate underexposure.

EOS-Programming: program mode without corrections.

Reason: the photographer allowed for a whole range of "errors" which combined to give the perfect end result. The silhouette was the result of an underexposure due to the subject being back-lit. The autofocus was allowed to find the perfect focusing point — the twigs at the centre of the frame.

Photo: Hermann Groeneveld

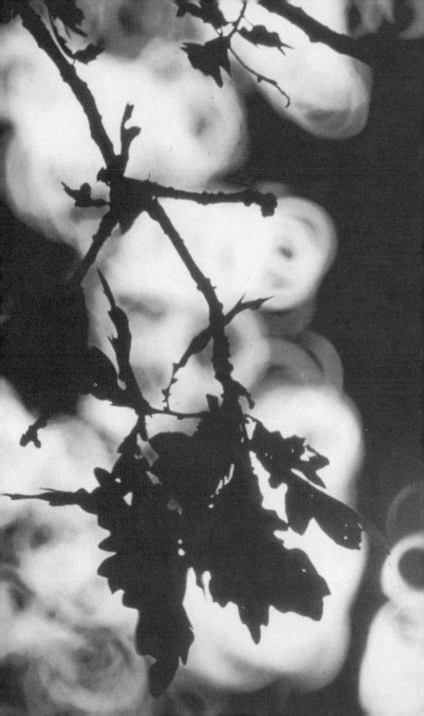

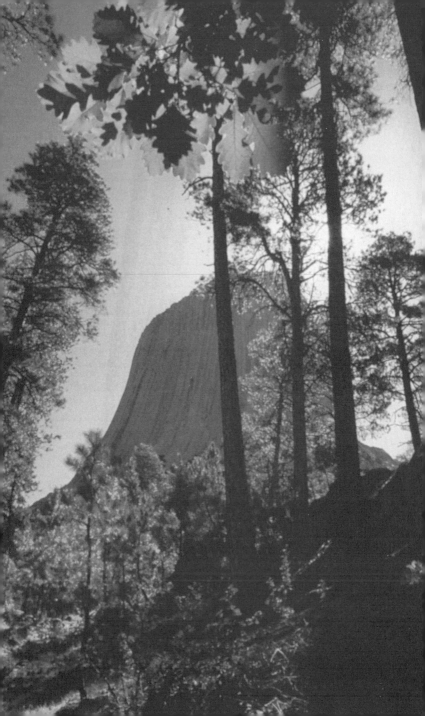

Description	Function
2000 22	Both the fastest shutter speed and the smallest aperture value blink to indicate overexposure.
1.8	The largest available aperture (smallest f/number) blinks in shutter speed priority mode to indicate underexposure.
22	The largest available aperture (highest f/number) in shutter speed mode blinks to warn of overexposure. It also blinks if the depth of field range metered in DEPTH mode cannot be attained.
30''	The display for the slowest shutter speed blinks in aperture priority mode to warn of underexposure.
2000	The display for the fastest shutter speed blinks in aperture priority to warn of overexposure.
dEP 1	Display indicating that the first distance metering had been effected in DEPTH mode.

EOS-Programming: program mode (full auto) without corrections.

Reason: the camera's automatic exposure program is taken to the limits of its capabilities, but modern chemical processing techniques "corrected" this shot to good effect. Shooting with colour slide film would have necessitated a compensation factor. Colour print films can cope with a wider contrast range as the above print from a colour slide proves. To start with the inexperienced photographer is better off with colour print film than with the more critical slide films *Photo: Klaus Lipa*

Description	Function
dEP 2	Display indicating that the second distance metering has been effected in DEPTH mode.
OP	Display for manual exposure setting, indicating that the aperture should be opened up for correct exposure.
OO	Display for correct manual exposure setting.
CL	Display for manual exposure setting, indicating that aperture should be stopped down for correct exposure.
+ 1.5 +/-	Display that an exposure compensation of + 1.5 stops has been effected.
- 2.0 +/-	Display that an exposure compensation of - 2.0 stops has been effected.
0.0 +/-	No exposure compensation has been entered.
bulb	Setting for exposures longer than 30 seconds. The count-down of the long exposure is displayed in seconds in the display panel. The clock counts three times to 30 seconds. The elapse of 30 seconds is indicated by one of the bar symbols of the film transport symbol. The total exposure of 120 seconds is therefore shown as 3 bars and 30 seconds.

Description	Function
Film cassette symbol	Blinks when film is being rewound.
Bar diagram next to film cassette symbol	Blinks if the film is not correctly loaded or the camera is blocked. Battery check display:- Three bars — batteries O.K. Two bars — keep spare battery handy One bar or no bar — replace battery. Film rewind display.
Film counter	Display of frame number. Self-timer countdown. Long exposure time display. Film rewind display.

Additional Features of the EOS 620

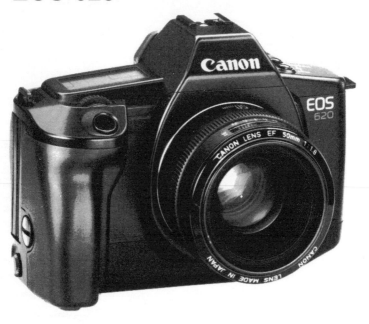

The operation of the EOS 620 is the same as that of the EOS 650 in practically all respects, but it offers a number of additional features that will appeal to professionals and advanced amateurs. The depth of field mode has been sacrificed, but this is a small price to pay for the extra facilities that are available on the EOS 620. The assessment of depth of field in any case is second nature to experienced photographers.

The first useful addition for action photographers is the ¹/₄₀₀₀ sec. shutter speed, which is capable of stopping the fastest action. The ultra-fast movement of the shutter blades required to produce this high speed also enables

the EOS 620 to have the high synchronisation speed of $\frac{1}{250}$ sec. for flash. This is invaluable when using fill-in flash in bright sunlight and for avoiding the ghosting and blurring that can occur if the ambient light is bright.

Film rewind is also faster. A 24-frame film will be rewound in 7 seconds, compared with 10 seconds for the 650. This, for sports photographers and photo-journalists, can make all the difference between success or failure.

One of the disadvantages of the LCD panel, now such a common feature of modern cameras, is that they can be difficult to read in dim light. Canon have made this easy for the EOS 620 owner by providing illumination for this panel. It is switched on by pressing the small button to the left of the Partial Metering/AE Lock button, situated at the top right-hand corner of the back of the camera, whereupon a soft blue glow makes the LCD panel visible to read even in darkness. The light is automatically extinguished after 8 seconds, or before by pressing the button again.

The EOS is fitted with the GR 20 grip as standard. This is equipped with a remote control terminal for connecting one of the Canon remote devices for operating the camera at a distance. The EOS 650 has the GR 30 grip without this feature. The grips are interchangeable, and for those who prefer it there is also the GR 10 grip with a strap which fits round the hand and is particularly suitable for photographers with large hands.

Program Shift Function

There are times when you may need a specific shutter speed or aperture but still prefer to be shooting in the program AE mode. The Program Shift function enables you to change the automatically-set shutter speed/ aperture combination of this mode. Make sure the main switch is set to **A** or (●). (This function cannot be used when the switch is set on the Full Auto position – the green rectangle). Press the shutter button to first

pressure point to meter the subject then turn the electronic input dial until the desired shutter speed or aperture value appears (once the shutter button has been pressed to first pressure point you can remove your finger because the display will be held for approximately 8 seconds).

Program shift characteristics of EOS 620

(EF 50mm f/1.8, — example with shift at EV13)

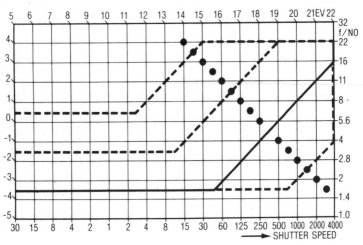

●indicates the shutter/aperture combinations in program shift function.

Auto Exposure Bracketing

Exposure with slide film is very much more critical than with negative film. There is no opportunity to compensate for under- or overexposure in the printing or to make colour corrections. Professional photographers will often "bracket" their exposures when the pictures are vital. This means that they take several frames, one at the metered exposure, and then two or three at intervals of overexposure, followed by the same procedure for under-exposure, probably in half-stop steps. The EOS 620 will

166

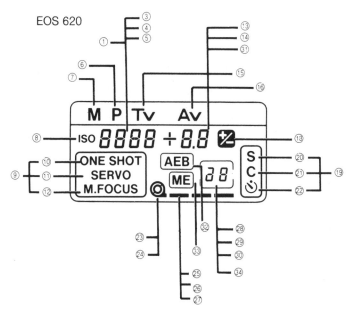

EOS 620

1 Battery check
3 ISO film speed
4 Shutter speed
5 Metered manual exposure level
6 Program AE
7 Manual
8 ISO indicator
9 AF mode
10 One-shot AF
11 Servo AF
12 Manual focusing
13 Aperture value
14 Exposure compensation value
15 Shutter-priority AE
16 Aperture-priority AE

18 Exposure compensation
19 Film winding mode
20 Single exposure
21 Continuous exposure
22 Self-timer
23 Film-load check
24 Film rewind completion
25 Film transport (wind/rewind)
26 Film wind completion
27 Battery check
28 Frame counter
29 Self-timer countdown
30 Bulb exposure time
31 Auto exposure bracketing value
32 Auto exposure bracketing
33 Multiple exposures
34 Number of multiple exposures

do this for you automatically. It will take three shots, one at normal exposure, one over- and one underexposed. The amount of under- and overexposure can be varied from + or − 0.5EV to + or − 5EV, in 0.5EV steps.

Open the switch cover and press the AF mode selector and the battery check button simultaneously for the 0.0 and **AEB** to appear in the LCD panel. This is held for 8 secs so you can take your fingers off the buttons and then turn the electronic input dial to the desired bracketing value. If you set 1.0 in the LCD panel, for example, the camera will automatically make three exposures in sequence of −1.0 step of underexposure, correct exposure according to the meter, and +1.0 step of overexposure. This function clears automatically when a sequence is complete. The focus remains locked during this procedure regardless of the AF mode. You can use neither bulb nor flash with this function. If you want to clear a set sequence before you start shooting, display the **AEB** and preset bracket value again by pressing the AF and battery check buttons and then turning the electronic input dial until the bracket value returns to 0.0.

Multiple Exposures
Sometimes, for creative effects, you might want to make more than one exposure on the same frame. The classic use of multiple exposure is to manufacture "ghost" pictures, but it might more seriously be used for recording stages in movement, for example of a dancer. With the EOS 620 you can take up to 9 frames with a single operation of the electronic input dial.

To operate multiple exposures, press both the shooting mode selector and the exposure compensation button simultaneously. The letters **ME** will then appear in the LCD panel indicating Multiple Exposure status, and the frame counter will read **1**. While keeping both these buttons pressed, turn the electronic input dial to the desired number of exposures, up to a maximum of 9.

While shooting the **ME** symbol will blink to indicate that the camera is in the multiple exposure mode. After the preset number of exposures has been made, the film will automatically advance to the next frame.

If you change your mind before you start shooting and want to return to single exposures; press the two buttons and turn the electronic input dial to return the frame counter to **1**. If you have already started shooting and you want to cancel the procedure; press the two buttons but turn the electronic input dial until the frame counter is blank.

If you are making more than one exposure on the same frame, obviously the frame will be overexposed unless you make some exposure compensation. This is done using the exposure compensation function as described on page 55. As a general guide for double exposure; set the exposure compensation at -1; for triple exposure at -1.5; for quadruple exposure at -2; and so on. However, this is only a guide, the actual amount of exposure compensation required will vary depending on the situation and you will find that your results will improve greatly with practice. It is best to make the first exposure of the series on a relatively dark subject so that the image of the next exposure will show up clearly. It is advisable not to make multiple exposures on the first or last few frames of a film. This is because, due to film curl, the images may not be in precise registration.

If you have been using a negative film, it would be as well to inform your processing house that you have made multiple exposures, otherwise they may not print those frames thinking they are failures.

Stop Press:
More Canon EF Lenses

Some of the lenses announced at the introduction of the EOS system and described earlier in the book, much to the disappointment of EOS enthusiasts, have not yet appeared in general production: notably the EF 50mm, f/1.0 L and the EF 28-80mm, f/2.8-4.0 L Zoom. However, in compensation, several more lenses are now available.

The gap in the wide-angle range is now filled by the EF 24mm, f/2.8. This is a very useful lens for architecture,

EF 24mm, f/2.8

interiors, or snapshots at close quarters. It has an angle of view of 84° and gives enormous depth of field, even at fully open aperture, and is capable of the most impressive wide-angle images. There is a slight curvature of the lines at the edge of the picture, but nothing like that produced by the Fisheye lens, and on most subjects is not noticeable.

The Compact-Macro EF 50mm, f/2.5 allows the EOS to penetrate into the close-up range and many people will prefer to use this as their standard lens. Its extra long extension allows reproduction ratios of up to 1:2, that is half life size, without the need for any accessories. As a

EF 50mm, f/2.5 Macro and Life-size converter EF

macro lens it is optically computed to give its peak
performance in the close-up range, with no distortion or
curvature of field. This makes it very suitable for copying.
The Life-Size Converter EF is designed to be used with
this lens to bring the reproduction scale to 1:1 i.e. to life
size. It is not suitable for use with any other lens.

Two zoom lenses foreshadowed in the earlier chapter
"Looking into the Future" have now appeared. The first
is the EF 35-135mm,f/3.5-4.5. This lens would be an ideal
choice for someone who wanted just a single lens to cover
all their requirements, from moderate wide-angle snap-
shots at 35mm to a reasonable telephoto. The second lens
is the EF 50-200mm,f/3.5-4.5. With both these lenses the

EF 50–200mm, f/3.5-4.5

standard lens is superfluous, unless the higher speed is of particular importance. It covers an angle of view from 12° to 46° and therefore the entire range of the standard to the telephoto or longer focal length will only be needed for special applications. For professionals and very critical amateurs there is available the 50-200mm, f/3.5-4.5 L. The construction of this lens includes elements with extremely low dispersion, the advantages of which have already been described. It is a lot more costly, but this is justified if you need extreme enlargements or want to project slides on large screens for public exhibitions.

Two zoom lenses, the EF 35-70mm, f/3.5-4.5 A and the new EF 100-200mm, f/4.5 A are restricted to autofocus

EF 100–200mm, f/4.5A

only. This means they cannot be focused manually but they do show a cost advantage.

Finally, there are two new high speed telephoto lenses. These are the EF 200mm, f/1.8 L and the EF 600mm, f/4.0 L. Both are ideal for sports and wild-life photography using available light. Their construction includes aspherical elements and UD glasses or florite, resulting in very low

dispersion. This means that chromatic aberrations, which become particularly troublesome with long focal length

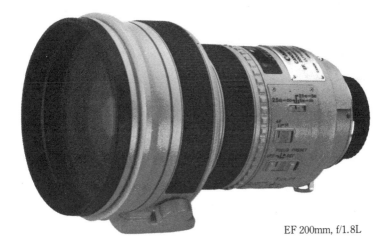

EF 200mm, f/1.8L

EF 600mm, f/4L

lenses, are greatly reduced resulting in much higher image quality. These lenses, together with the EF 300mm, f/2.8 L, are of extremely high speed for their focal lengths.

173

A new extender, the Extender EF 1.4X, like the already
described Extender EF 2X, has been designed exclusively

Extender EF 1,4x

for these three lenses. In this case the focal length is
extended by 1.4X with a cost in aperture reduction of only
one stop. The effect of these two extenders is as follows:-

Lens	+ Extender 1.4X	+ Extender 2X
200mm, f/1.8 L	280mm, f/2.5	400, f/3.6
300mm, f/2.8 L	420mm, f/3.9	600, f/5.6
600mm, f/4 L	840mm, f/5.6	1200mm, f/8

Data on the New EOS Lenses

Lens	Angle of View	Construction	Min. Aperture	Closest Focusing Distance (m)	Filter Size (mm)	Length (mm)	Weight (g)
EF 24mm f/2.8	84°	10-10	22	0.25	58	48.5	270
Macro EF 50mm f/2.5	46°	8-9	32	0.23	52	63.0	280
Life-Size Converter EF	–	3-4	–	–	–	34.9	160
EF 200mm f/1.8 L	12°	10-12	22	2.5	48	208.0	3000
EF 600mm f/4.0 L	4° 10′	8-9	32	6	48	456.0	6000
EF 35-70mm f/3.5-4.5 A	63°-34°	8-9	22-29	0.39	52	63.0	230
EF 35-135mm f/3.5-4.5	63°-18°	12-16	22-29	1.5	58	94.5	475
EF 50-200mm f/3.5-4.5	46°12°	13-16	22-29	1.5	58	146.4	690
EF 50-200mm f/3.5-4.5 L	46°-12°	14-16	22-29	1.5	58	145.8	695
EF 100-200mm f/4.5 A	24°-12°	7-10	32	1.9	58	130.5	520
Extender EF 1.4X	–	4-5	–	–	–	27.3	200

ACCESSORIES WELL WORTH LOOKING AT!

OP/TECH

The world's most comfortable cameras, bag and tripod straps (binoculars too). Op/tech has a built-in weight reduction system that makes equipment feel 50% lighter and 100% more comfortable. From the famous 'Pro-Camera Strap' to the 'Bag Strap' and the 'Tripod Strap', the style, colours and comfort which along with the non-slip grip, ensure that you have a wonderful combination of comfort and safety.

BAG STRAP

The **OP/TECH USA Bag Strap** is the answer to the problem of carrying a heavy bag for extended periods of time. By combining the patented weight reduction system with the Non Slip Grip™, you have the perfect strap for camera/video bags and cases as well as garment bags. Adjustable from 29" to 52", this strap is one of a kind. You will feel the difference!

STO-FEN

The ultimate lightweight diffuser system for high powered modern flashguns. Sto-Fen offers the 'Omni-Bounce' for overall soft diffusion – often called the "softie" – which weighs in at just 15 grams and the 'Two-Way' Bounce Card for those who prefer to direct diffused light from their flash. The 'Two-Way' only weighs 25 grams, so it adds almost nothing to the overall weight of the flash. Sto-Fen are the lightest weight, most effective flash diffuser products on the market today.

PELI-PELICAN CASES

Watertight and airtight to 30 feet for the ultimate in protection. Constructed of light weight space age structural resin with a neoprene "O" ring seal and exclusive purge valve. Supplied complete with pre-scored pick n'pluck foam or padded dividers. Also includes locking flanges, massive multiple latches for absolute security and best of all, a comfortable molded grip handle.

JERSEY PHOTOGRAPHIC MUSEUM

OVER 1000 CAMERAS AND PHOTOGRAPHIC
ACCESSORIES ON SHOW FROM 1850 TO THE PRESENT DAY

EXHIBITION OF PHOTOGRAPHS IN THE GALLERY
CONSTANTLY CHANGING

**OPEN 0900 - 1700 HOURS MONDAY-FRIDAY
CLOSED PUBLIC HOLIDAYS
ADMISSION CHARGE - £1**

THE PHOTOGRAPHIC MUSEUM IS LOCATED IN THE CHANNEL
ISLANDS BETWEEN ENGLAND AND FRANCE IN THE LARGE
**HOTEL DE FRANCE, CONFERENCE & LEISURE COMPLEX
ST. SAVIOUR'S ROAD, ST. HELIER,
JERSEY, C.I. JE2 7LA
TEL. (01534) 614700 FAX (01534) 887342**

COMPLETE USER'S GUIDE

POPULAR

MODERN CLASSICS

This series includes:
CANON CLASSICS
featuring:- F1, FTb, EF, AE-1
AE-1, A-1 & AE-1
OLYMPUS CLASSICS
featuring:- OM1, OM2, OM2
Sport-Program, OM4/OM3
OM10 & OM40 Program.
NIKON CLASSICS
featuring:- F, EL, FT2, FM
FE2 & FA
NIKON F2 CLASSICS
featuring:- F2 Photomic, F2S
F2SB, F2A & F2AS
PENTAX CLASSICS
featuring:- ESII, Spotmatic F
K2, KX/KM, ME/MX
& ME super

New Titles in Preparation: Rolleiflex SL35, SL35E
& VOIGTÄNDER

For a complete list of the many
Hove Foto Books
and User's Guides
for Modern, Classical
and Collectors' Cameras,
write to:-

Worldwide Distribution:
Newpro (UK)
Old Sawmills Road
Faringdon
Oxon
United Kingdom
SN7 7DS
Tel: (01367) 242411
Fax: (01367) 241124

Or from the Publishers:
Hove Foto Books
Jersey Photographic Museum
Hotel de France
St. Saviour's Road
Jersey
Channel Islands
JE2 7LA
Tel: (01534) 614700
Fax: (01534) 887342

PRACTICAL photography

HELPS YOU TAKE BETTER PICTURES

—

Every issue is packed with essential techniques, ideas, equipment and inspiration to improve your pictures.

—

PRACTICAL photography

TOP PHOTO TECHNIQUES

GREAT PHOTO IDEAS!

CHOOSE THE RIGHT CAMERA

PLUS NEWS AND OPINION FROM THE WORLD OF PHOTOGRAPHY